THE CHICAGO ART SCENE

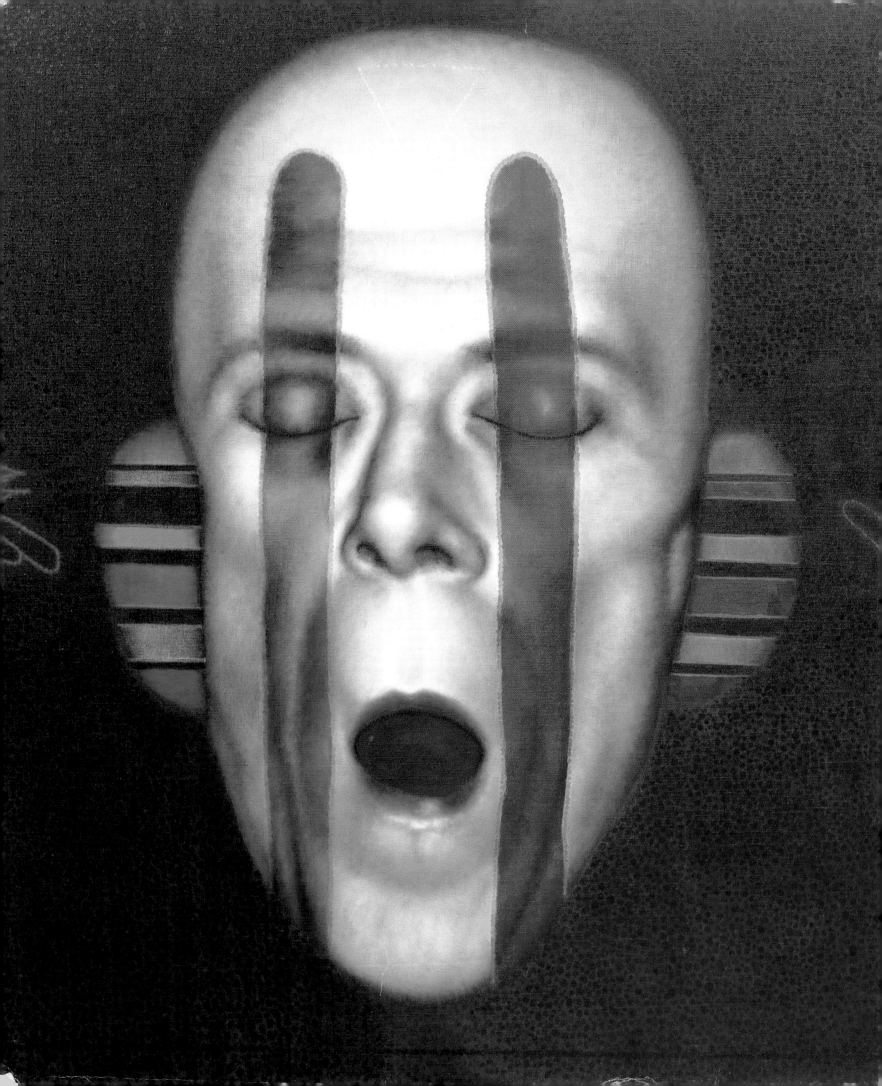

THE CHICAGO ART SCENE

Ivy Sundell

CROW WOODS PUBLISHING

FOR MY CHILDREN, VICTORIA AND VALENTIA

Published by: Crow Woods Publishing
 Post Office Box 7072
 Evanston, IL 60204

Distributed by: ACCESS Publishers Network
 6893 Sullivan Road
 Grawn, MI 49637

Printed by Toppan Printing Company in Hong Kong.

Publisher's - Cataloging-in-Publication Data
Sundell, Ivy.
 The Chicago art scene / Ivy Sundell.
 p. cm.
 ISBN 0-9665871-9-7 (pbk.)
 1. Artists—Illinois—Chicago. 2. Art, American—Illinois—Chicago. 3. Art, Modern—20th century—Illinois—Chicago. I. Title.
 N6535 1998
 709'.2'2

Library of Congress Catalog Card Number: 98-73086

Copies of this publication can be obtained from the publisher for $30 each, including shipping and handling. Illinois residents add $2.24 per copy for sales tax.

FRONTISPIECE:
Ed Paschke
Interface
(cat. no. 133, detail)

PAGE 10:
Grace Cole
From Vermeer's 'Red Hat'
(cat. no. 1, detail)

PAGE 13:
Michele Maria Mitchell
Moving Toward the Light
(cat. no. 108, detail)

Contents

Foreword

While there are books covering individual artists, and magazines and newspaper articles covering their current exhibitions, there is a lack of books featuring artists as a community in the local area where they live. In particular, Chicago is the home of many fine art programs, most notably the School of the Art Institute of Chicago, where many artists in the area have studied. These programs draw artists from all over the world to study for a period of time, many of whom eventually settle here. *The Chicago Art Scene* recognizes the influence this city and its greater environs have exerted over the art community by presenting a collection of their work.

Thousands of artists reside in the Chicago area. To make this book effective in highlighting artists who produce good work, the scope was limited to two-dimensional media, excluding photography. What was loosely defined as the Chicago area covered the city and its surrounding suburbs as well as smaller cities nearby such as Gary, Indiana. Finally, the artwork was juried by a panel of three experienced jurors selected through the recommendation of the Chicago Artists' Coalition, an organization with over two thousand five hundred members.

As the primary object of this book is to showcase good Chicago-area artists, rather than necessarily established artists, much effort was expended to attract their attention. In addition to responses to advertising and contacting various galleries and art leagues, a large portion of the submissions came from individual artists passing the word to their friends. Special attention was given to attract a wide spectrum of media, as well as of the ethnicity that the Chicago area encompasses. The collective effort of many organizations and individuals culminated in a book representative of some of the best fine artists in the area.

Acknowledgments

As with any publication of this magnitude and ambition, many individuals and organizations contributed to its success. It is impossible to mention all by name. In some cases, a few minutes of one individual's time led to the desired result; in other cases, the amount of time spent and efforts expended were extensive. Oftentimes, the individuals may not have realized the significance of their effort but I know their generosities. I want to give my thanks to these individuals even if I do not mention them by name below. The following individuals helped make this book a reality.

IN SEARCH OF JURORS

The search for jurors would not have gone so smoothly if it weren't for the help and recommendations from Arlene Rakoncay of the Chicago Artists' Coalition. I want to thank Arlene and the staff at the Chicago Artists' Coalition for passing the word to potential jurors. The potential jurors whom I interviewed and who submitted resumes were courteous and made many suggestions about the jury process, for which I am grateful. I also talked at length with Colette Cooper of the Wilmette Arts Guild who offered insight into the jury process. I am also thankful to Grace Cole for recommending Marta Pappert as a panel member.

IN SEARCH OF ARTISTS

The search for fine artists was relentless and I am grateful to all individuals and organizations which helped pass the word. I am again thankful to Arlene Rakoncay of the Chicago Artists' Coalition for her many suggestions on ways to reach more artists and art organizations.

Other individuals who helped put notices on bulletin boards include Grace Cole, one of the jurors for this book, and Sue O'Halloran, a storyteller, diversity workshop trainer and personal friend.

Many leaders of art organizations helped spread the word to their members. Below are a few whose impact was strongly felt and I appreciate their attentiveness to this project: Nancy Fortunato, President of the Midwest Watercolor Society, brought the book to the attention of Society members through a number of informal artists gatherings; David McElroy, President of the Midwest Pastel Society, talked to several pastel artists himself, prompting them to enter their work for this unique publication; Garry Henderson at the Loyola University Medical Center and the Riverside Arts Center provided a list of fine artists which he painstakingly prepared; Maureen Bardusk of Northwest Cultural Council spread the word to artists in the Council at a time when there was no scheduled newsletter; Pat Galinski, Founder of Artists of Rogers Park, passed the word at her regular staff meeting and supplied contact information for several artists in her organization; Ron Manderscheid and Patti Byer at the Northwestern University Settlement House took time out of their busy schedule to give me assistance and sent a mailing to their hand-selected artists on my behalf.

A number of galleries in the Chicago area responded most enthusiastically to my request to pass the word along to the artists they represent. I want to thank Julia Fischbach of The Vedanta Gallery and Tony White of Klein Art Work for their kindness and assistance. The owners of Belloc Lowndes Fine Art, Wood Street Gallery, Lyons-Wier Gallery, Time and Life

Building Gallery and Dramaticus Fine Art were all very prompt in circulating my notice among the Chicago-area artists they represent.

The search for artists was greatly helped by many who submitted their work and also passed the word to their artist friends. I am also thankful for all the artists featured in this publication—for their faith in this project and for their help in providing various details about their work.

PEER REVIEW

I am grateful to my reviewers for their attention to details and their generosities with their time: Jeannie Araujo, who was previously with Encyclopædia Britannica and a mother of two young children; Charlie Seminara, who is an artist and graphics designer; Thomas Sundell, who is a writer and consultant; and Bunny Zaruba, who leads the Water Street Design Group in Sausalito, California.

TECHNICAL ADVICE

Charlie Seminara also provided technical advice concerning computer system, software, layout, etc. throughout the project. He traveled a long way to my home to help me at times. Being an artist himself, he was always sensitive to how the artists' work and statements are displayed on the page. I consider myself most fortunate to have his help. Bunny Zaruba brought to my attention the latest technology in color printing, for which I am grateful.

EQUIPMENT

Andrea Kellinson of Evanston Arts Council was kind enough to lend me the slide carousels that she uses for the Lakeshore Arts Festival. Our discussions on many aspects of the jury process gave me insight on the common issues and possible solutions to the jurying.

SPECIAL THANKS

I would like to give special thanks to my husband, Tom, for his conception of this book and for always thinking ahead of my needs and rearranging his busy schedule to accommodate them. Without his constant help and encouragement, this book would not have been possible.

Introduction

This is not simply a picture book of Chicago-area fine artists. The essence of this publication is in the artists' statements of intent and their biographies. Accordingly, the images are carefully selected to support the artist's statement and to enlighten what each artist brings to the art scene.

This book endeavors to provide an educational impact to its various readers. An artist may glimpse what other fellow artists have done to achieve recognition and what pathways they have followed in their careers. Non-artists may find inspiration to produce their own art or at the least, develop an understanding of the internal and external influences that shape an artist's work and art career, and an appreciation of the personal vision behind these extraordinary works of art.

Attention is given to the variety of art in an artist's career rather than solely current work, which may be limited to a particular theme. The artwork featured may span decades or may represent several different media in which an artist works. Given this interest in capturing variety, the book is organized in the most straightforward fashion—without categorizing any artists or their artwork based on style, subject matter or media. Instead, the artists are presented alphabetically.

Although this is not a catalogue focusing on each piece of artwork as an end in itself, the works are identified by their title, dimensions, media and year of completion to give perspective to their creation. The media include, but are not limited to: oils, acrylics, watercolor, pastel, pen and ink, pencil, charcoal, prints (etching, monoprints and monotypes) and quilt. In cases of mixed media pieces, attention was given to specify those media either in the artist's statement or the description of the artwork.

From the artists' standpoint, this is another means of promoting their work. Artists use a great variety of venues to exhibit their work—from galleries to art fairs to juried exhibitions. A recent trend is the proliferation of artwork in coffee shops and restaurants. A yet newer means of self-promotion involves the creation of a web page on the internet, catering to our growing population of internet users. Should there be an interest in contacting the artists, this publication includes a directory listing the artist's telephone number, e-mail address and WEB page url, if available.

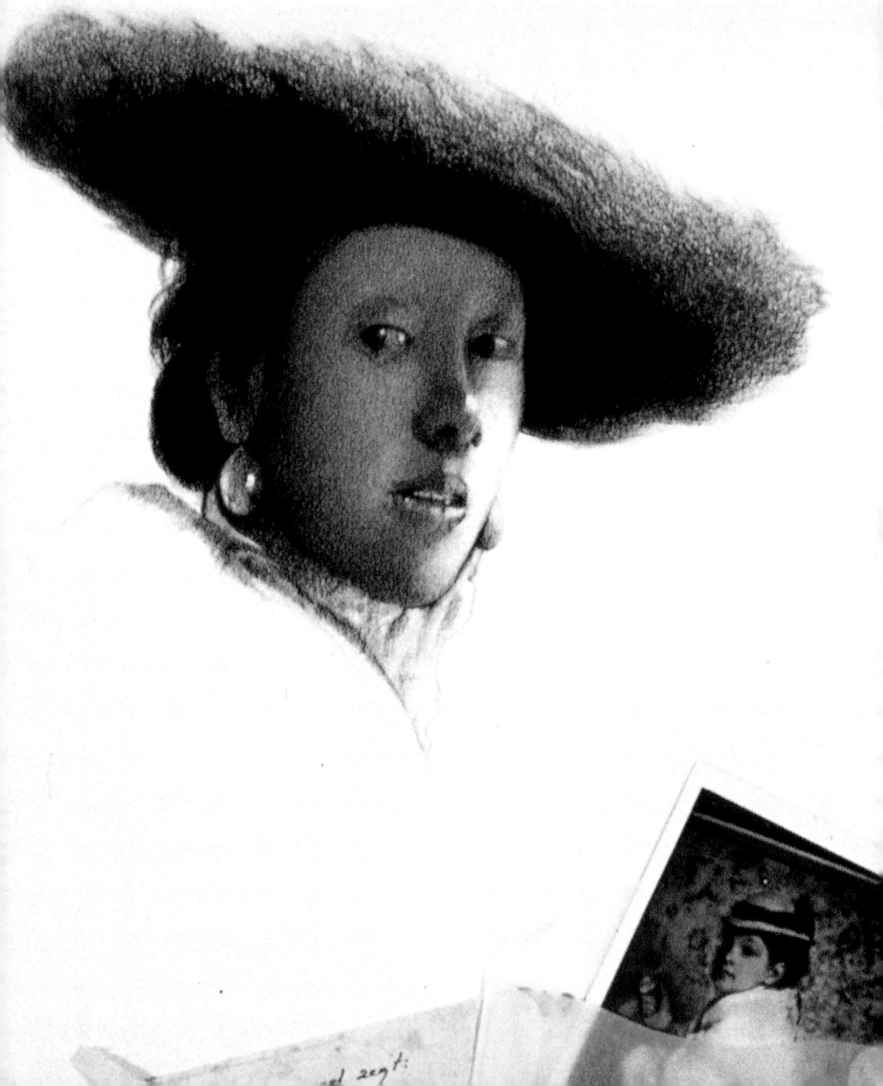

Jurors

Tim Ade

ON JURYING

"It is an accepted fact that looking at slides of art is not the best way to jury the work, but due to convenience and space requirements it is the tool that most jurors are faced with, and most artists must accept. Given that fact, I was impressed with the majority of artwork that was presented in this slide format.

The jurying room was professionally equipped and the identification of the 550-plus slides was very well organized. Our jury duties consisted of reviewing each slide carousel twice. The first viewing served as an introduction and overview of the work, and the second viewing as the opportunity for review and selection. It was a slow and deliberate process which gave each artist close scrutiny by each jury member. Discussions were limited during the viewing and the individual voting process was confidential.

When studying the works, I looked for visual impact (strong and subtle), personal vision, potential for growth and professional maturity. I feel confident that the artists I selected exhibited consistency in my criteria, will continue to produce and will find established venues for their work to be seen."

BACKGROUND AND JURY EXPERIENCE
Ade was Director of the Fine Arts Department Gallery and Adjunct Professor in Fine Arts at Loyola University of Chicago for 12 years before joining the Mitchell Museum in 1997 as the Exhibits Coordinator. Before that, he was Assistant Professor of Art and Director of Printmaking Department at Northwestern University. He has also taught printmaking, and advanced drawing and painting at six other colleges and universities, numerous art leagues and art centers, and 8th to 12th grade at North Shore Country Day School in Winnetka.

Ade has been very active professionally. He was the Panel Member of three programs of the Illinois Arts Council, Advisory Committee Member of D'Arcy Museum of Renaissance Art at Loyola University, a member of the Board of Directors at the Chicago Artists' Coalition, and many more.

He has acted as juror for many regional, national and international art shows, such as the 5th International Colored Pencil Society Exhibition, 9th Midwest Pastels '95 —National Exhibition, and the 11th Midwest Print Show.

Grace Cole

ON JURYING

"Jurors only saw projected slides of the work and did not know the identity of the submitting artists. As one of three jurors using specific guidelines for the process, I selected work based on several reactions: The first was an overall 'gut' reaction—Do I like this work or don't I? Next, I evaluated each piece presented—I studied the technical ability of the artist and the professional quality of the presentation. I evaluated the uniqueness of the work. I asked myself, 'If I had an unlimited budget, would I buy this art?'

I noticed many excellent works by both students and professional artists, presented in all styles, subject matter and size. I was particularly struck by many artists' high degree of skill in using the basic design elements, as well as their overall professionalism to present such diverse, original, expressive and thought-provoking ideas."

BACKGROUND AND JURY EXPERIENCE
Cole is an artist who works in oils, pastel, carbon and charcoal. She is a Board Member of Friends of the Chicago Cultural Center and an Executive Board Member of the Illinois Chapter of National Museum of Women in the Arts. She has taught drawing and oil painting at the Old Town Triangle Association, Prairie State College, Suburban Fine Arts Center and at her studio. She is represented by Portraits, Inc. in New York and Byron Roche Gallery in Chicago.

Cole has acted as juror for a number of art fairs, including the Old Town Art Fair in Chicago and the Homeward Flossmore Art Fair in Homeward, Illinois.

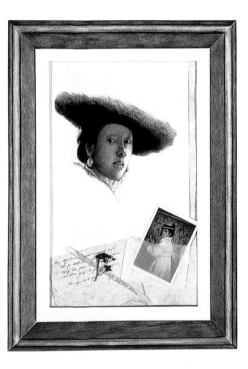

1. *From Vermeer's 'Red Hat'* by Grace Cole
1996
Carbon Pencil on Paper and Mixed Media with Hand-Drawn Frame
30" x 22½"

Marta Pappert

ON JURYING

"Every jury is different and becomes something other than the sum of its parts—much as a work of art does. When jurying, for me the initial response is an immediate and instinctive reaction to the piece. Then I examine the work to analyze the response—color, composition, use of media, technical ability (although this is difficult when jurying slides), originality of the idea, what the artist wants to say and how well does he succeed. I like to see a consistency of ability, but not necessarily idea, throughout the body of work submitted by each artist. This demonstrates the artist's objectivity in editing himself—an often lacking talent, but one each artist should learn and exercise.

As with all jurors, there are areas of my judgement that are colored by personal preference that I will share with you. When the making of the art is going well, the passion and pleasure in its creation shines through the work itself. This *shine* is what makes for a strong visual experience that I find inexplicable but easily discernable. I also enjoy seeing the work of an artist who obviously uses his medium well, with virtuosity, making strengths of the medium's weaknesses.

The quality of artists assembled for this book was a pleasure to jury."

BACKGROUND AND JURY EXPERIENCE
From 1972 until 1986, Pappert was Director of the Art Rental and Sales Gallery for the Woman's Board of the Art Institute of Chicago, which rented and sold original works of art juried from contemporary Chicago area artists. In 1986, she started her own business as a corporate art consultant. She is President of the Board of Trustees of the Chicago Academy of the Arts—a high school for the visual and performing arts, and an Advisory Member of the Board of the Chicago Artists' Coalition.

She has served on many juries and has organized somewhere between fifty and seventy-five of them. In 1990, she curated an eight-artist exhibition at the State of Illinois Art Gallery entitled 'Death' in which two artists in this book, Betty Ann Mocek and James Mesplé, were featured.

Author's Note on the Jurying Process

PROCEDURE
The jurors were asked to rank the artists' work from 1 to 5 (1 being the least and 5 being the most) in the areas of originality, technique, composition and emotional appeal. They also indicated which slides were deficient as photographic slides, such as glare on the painting, work photographed at an angle, too dark, etc. In all cases where a chosen artist had deficient slides, replacement slides or transparencies were requested and received.

JURORS' DISCUSSIONS
An initial concern of the jurors, that the body of work as a whole would be too poor in quality due to the wide solicitation of submissions across communities rather than solely among the established artists, quickly dissipated as the slide showing progressed.

Although the artists were not identified by name, the distinctive style of a few were quickly recognized by the jurors.

The jurors marveled at the number of good realists represented in the midst of the abstract, surrealist. Of course, not all realists who submitted their work were selected. The proportion of realists to surrealists included in this book was comparable to that of the rejected artists.

FINAL SELECTIONS
Of the 112 artists who submitted slides, the top ranking 68 were included in this book. In general, the jurors agreed on the quality of the artists' work. There were, however, a dozen or so artists who received mixed reviews from the jurors. They were ranked high by one juror but low by another juror. Another group of artists scored high in one category but not in another; for example, a number of artists scored low in 'originality' but not in other categories. In both cases, no weighting was applied to the scores to offset the difference in the jurors' view or the variance in the rankings of the different categories. The average score for each artist ultimately determined who was selected and who was not.

Artists

PRESENTED IN ALPHABETICAL ORDER

David H. Abed

"Working on still life painting allows me the freedom to solve problems that may occur in the design aspect (the abstract elements) of composing and/or orchestrating a composition. Line, values, shapes, textures and color are worked out in this stage, which strengthens my creativity in other aspects of my work such as portraits, landscapes and narrative figurative composition."

BIOGRAPHY
Abed received his Bachelor of Arts in Fine Art from the Ray College of Design in Chicago in 1996. He also attended the School of Representational Art in Chicago. He was the Chairperson of the Visual Arts' Curator for Around the Coyote and curated for the Around the Coyote Gallery.

2. *Dana*
1997
Oil on Linen
42" x 44"

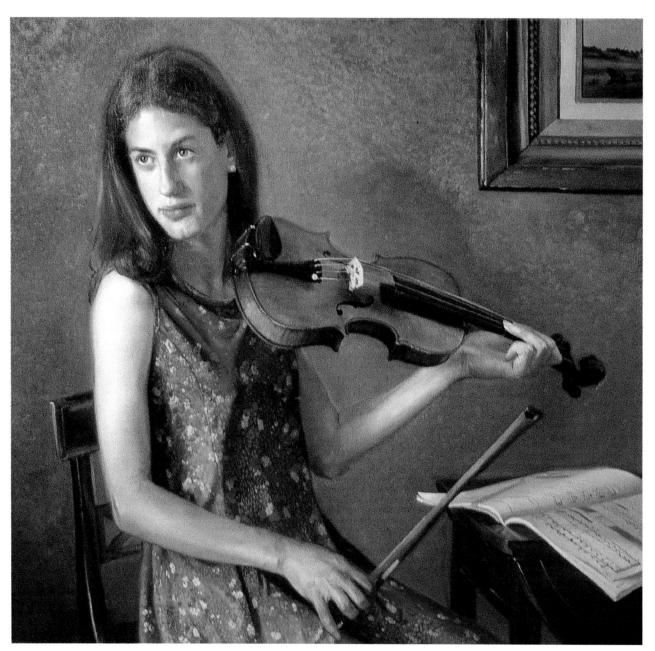

3. (below)
Dana, Detail

4. (below)
Streets of Gold
1997
Oil on Linen
16" x 20"

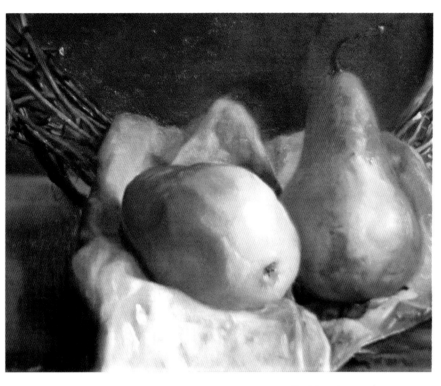

5. (above)
Pears
1997
Oil on Linen
9" x 12"

Abed has taught portrait and figure drawing and painting at the Suburban Fine Arts Center and privately.

His work has been exhibited at various galleries in Chicago, such as the Central Studio Gallery, Roberto Lopez Gallery, Murmur Box Gallery, Artists' Liaison ATC Gallery, Red Minnow Gallery and Romero Design Showroom.

Robert Amft

"At the time I graduated from the School of the Art Institute, there were really only two choices for a young artist—teach, or do commercial art. Since my father and two uncles were commercial artists, I naturally chose that direction.

Now that I have retired, I am producing painting, photography and sculpture. I paint out of habit. Every morning I get up and paint. I am also actively seeking a good gallery."

BIOGRAPHY
Amft was born in Chicago and grew up during the Great Depression. After graduating from high school, he worked for a year for the New Deal's Civilian Conservation Corps in the Sawtooth Mountains of Idaho before enrolling in the School of the Art Institute of Chicago. He entered advertising and publishing design upon graduation and has taught at the Ray School in Chicago and the New Orleans Academy of Art.

6. *Interior*
1994
Collage
70" x 72"

Amft has won many prizes for his work. His painting, *Sunday Afternoon in Lincoln Park*, won First Price at the New Horizons Annual Exhibition in 1975, and his painting, *Head*, won the Renaissance Price at the 1975 Chicago Vicinity Show. In 1985, he won a Painting Award from Beverly Art Center and in 1986, he was the Curator's Choice at the Art Sales and Rental Gallery of the Art Institute of Chicago. He has also exhibited his watercolors at International Watercolor Shows as well as locally. His photography and design have won over fifty awards and have been reproduced in *Graphis Annual*, *N.Y. Art Director Annual*, *Life*, and *Photo Graphis*. His sculpture, *Dog*, won $1,000 award in the 1994 Beverly Art Center Annual Exhibition and his *Whistler's Mother* sculpture won the Best of Show Award at the 1997 'Later Impressions' exhibit held at the James R. Thompson Center in Chicago.

7. *After Botticelli*
 1997
 Acrylic
 84" x 60"

Christopher Baima

"I was born and raised in a small community in Central Illinois called La Salle-Peru Township. Throughout those early years, I continually developed my artistic senses and abilities. At the age of 16, I lost my father to cancer. Two years later, I left home to discover life for myself. I majored in Art History and Painting in college. Then I made a regretful decision to marry. The relationship dissolved after two years, forcing me to leave school and take on a second job. I moved away to forget…to get away. Then, my life began.

I saw everyday life and everyday people in a different way. I began to draw my own conclusions. I began to live life for myself, adapting and adhering to my own ideas of morality and spiritual beliefs. This enlightenment has allowed me to perfect my abilities and senses as an artist in the truest sense of the word.

I'm only 24 years of age now. Looking ahead, I see some very troubling times for our society. But I know that my purpose in life is to make sense of everything and make it easier for everyone else to understand these confusing and changing times. Whether I achieve this through music, literature or visual art, that is the role I must play in this life."

8. *The Triumph of Evil over Good*
1994
Acrylic on Masonite
48" x 30"

BIOGRAPHY
Baima attended Rock Valley Community College in Rockford, Illinois for one and a half years. He had displayed his work at his college and at a number of cafes in the Rockford area.

9. (left)
America the Beautiful
1994
Acrylic on Canvas
39¾" x 30"

10. (right)
Contemplation
1995
Acrylic on Canvas
47½" x 41½"

Lee Barth

"After experimenting with different media, my technique began evolving in 1982. I felt I was limited in portraying everything I visualized or experienced with my traditional technique. With color and shape, I wish to involve the viewer emotionally with the greatness of a mountain, the song of the sea and colors of a desert or a flower. Many are places I have visited, Bible verses or dreams.

11. *Genesis I (The Second Day)*
 1998
 Oil Monoprint, Hand Transfer
 18" x 14"

My method of a hand transfer using glass or Masonite plates to transfer oils directly to a gessoed surface makes each of my paintings unique. I do not use a press of any kind. This method of painting has freed me to create a painting from my imagination or memory or something I've seen or read. I have to be alone and concentrate on what I'm doing: color, design and feeling. What's a painting without arousing feeling in the viewer, especially me.

After ten years of perfecting this method, these paintings do drain me both physically and mentally. Who knows what I'll try to add to them next? You can't let art lead you, you have to lead art. After all, Browning said, 'If you don't reach and dream, what's heaven for?'"

BIOGRAPHY

Barth graduated from Harrison Academy of Art in Chicago. She also attended the American Academy of Art and took graphics and independent workshops at the Oakton Community College. She worked in Chicago in design and layout. Then she became an assistant art director and later a freelance artist. She has taught and demonstrated collage and painting techniques in the Northwest and Chicago Park Districts and various art leagues. Her father was Erich Schmidt, a Chicago artist.

Barth's work has won the Northern Indiana Art Association (NIAA) Salon Show Awards at the Midwest Print Show. She has also exhibited her work at juried shows, including Oak Brook Invitational Exhibit, Old Orchard Juried Exhibit, Invitational Old Capitol in Springfield, and Oil Painters of America National Juried Exhibition. Her work is in many corporate and university collections.

12. *Enthroned So High*
1997
Oil Monoprint, Hand Transfer
22" x 17"

Heather Becker

"I am currently investigating the figure and its power to communicate psychological states of modernity. A spontaneous and simplistic image is developed using movement, tension and emotion. I strive to convey uninhibited and primal aspects of my emotional history. The developed image ultimately creates an inherent correlation between the painting and the viewer—an intimacy."

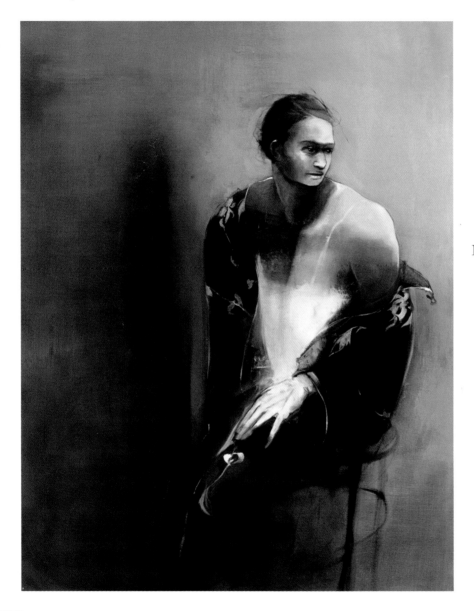

13. *Carriage*
1997
Oil on Linen
64" x 50"

BIOGRAPHY

Becker attended Glassell School of Art and the Contemporary Arts Museum in Houston, Texas. She received her Bachelor of Fine Arts degree from The School of the Art Institute of Chicago in 1989 and studied painting and drawing at The International School of Art in Italy. She has won numerous grants and awards, such as the National Competition Award from Goldkey Foundation, Houston for four consecutive years; a National Finalist Grant from the National Foundation for Advancement in the Arts, Miami; and an International Grant from Elizabeth Greenshields Foundation, Canada.

Becker's solo exhibitions appeared at the Gwenda Jay Gallery, Chicago; Southwestern Michigan College in Dowagiac, Michigan; and Two Illinois Center, Chicago; in addition to the four galleries that represent her. Her work also appeared at many group exhibitions, including the Art Chicago International Exposition in 1993, 1997 and 1998 at the Navy Pier; the International School of Art Gallery exhibition at Umbria, Italy; and the International School of Art Benefit Exhibitions in 1994 and 1995 in Naples, Florida. She is represented by Lyons-Wier Gallery in Chicago, as well as Atrium Gallery in St. Louis, Malton Gallery in Cincinnati and Galerie Art et Communication in Paris, France.

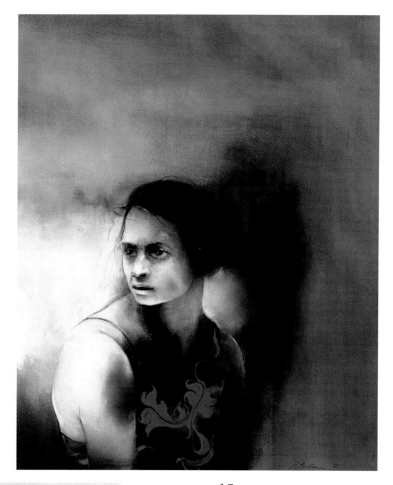

14. (below)
Consonance
1997
Oil on Linen
60" x 80"

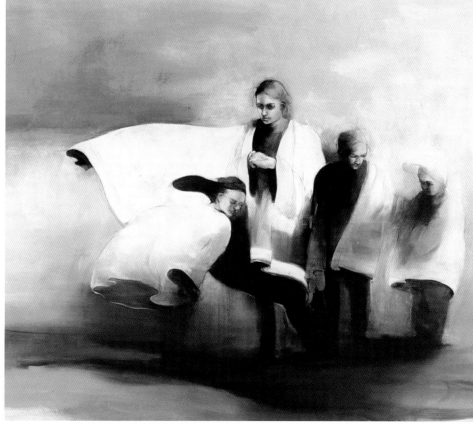

15. (above)
Grace
1997
Oil on Linen
29" x 24"

Geoffrey Bent

"I've always been attracted to the anecdotal side of an image—to its capacity for visual metaphor. The 'what' of a painting is usually its weakest element, even among many great artists; yet the 'what' in art as in life is inescapable. Put an axe or a pair of bikini briefs in the middle of any picture and try to avoid the gravity of their influence. Narrative not only acknowledges life's specificity, it celebrates it. The extensive writing I've done has also made pictorial narrative particularly congenial for me.

Because of these sympathies, I employ a wide range of subjects. I have begun an ambitious series of visual variations structured like musical variations around a given theme.

16. *Minimum Wage*
1997
Oil on Canvas
38" x 38"

This structure also attempts to supply the pictorial with the one element it does not share with either music or writing: sequential development. Individual scenes vary the overall content of the series by leading the viewer from the comic and critical to the poignant and mysterious. I have just completed the third set of these variations and I have fifteen more planned."

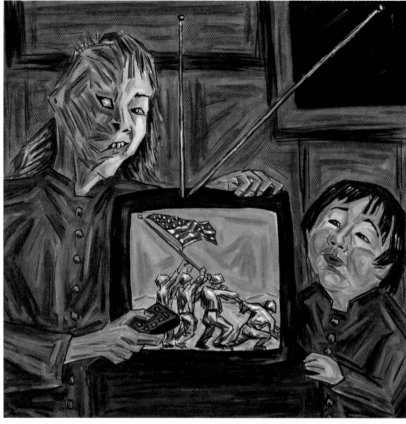

BIOGRAPHY

Bent has won many competitions around the country, including the 15th National Exhibition at the Louisiana Museum of Art, the 25th National Exhibition at the Pennsylvania Museum in Allentown, and the 19th Annual Open Competition at Salmagundi Club in New York. He received the first place medal for the 1993 Indianapolis, Indiana Regional Competition. Locally, his work has been exhibited at the Hyde Park Art Center, Beverly Art Center, Chicago Cultural Center, Northwest Art Council Gallery and the ARC Gallery.

17. (above)
Vietnamese Woman and Her American TV
1997
Oil on Canvas
32" x 32"

18. (right)
Three Grins, One Grimace
1997
Oil on Canvas
32" x 32"

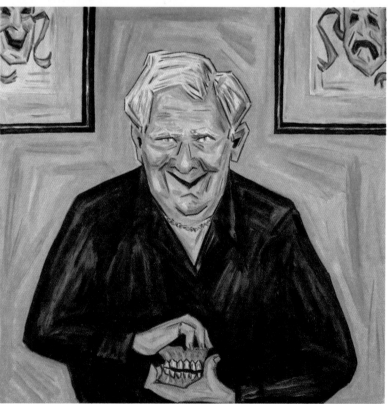

George Black

"I am investigating form, color and symbol. The hieroglyphics content of some of my paintings arrives upon the canvas completely spontaneously. I neither sketch nor plan the 'phrases' of the work. These figures and signs may have some origin in the subconscious mind. My intent is to probe the functioning of these non-referential alphabets, to question the language function at its most elusive level, and at the same time concern myself with the creation of beautiful paintings, which are of course quite useless."

19. *Eight*
1997
Acrylic on Canvas
43" x 43"

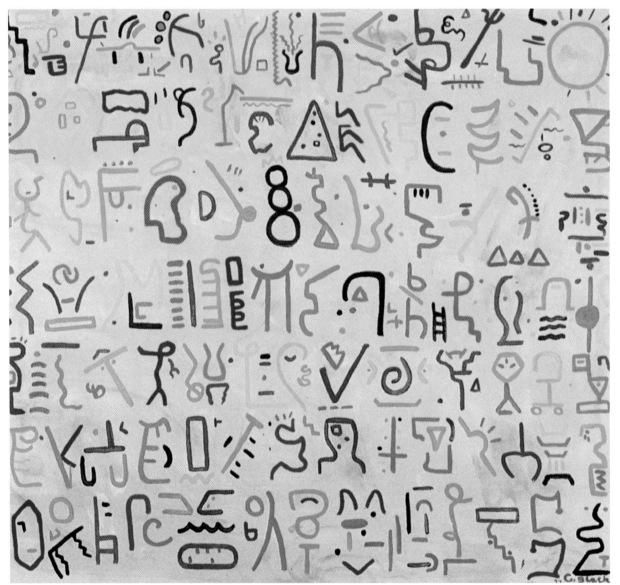

BIOGRAPHY

Born and raised in Chicago, Black has travelled extensively in Europe, making contact with modern European painting and culture. She has been painting continuously for the past six years. She is also a music composer and a poet.

20. *Music*
1997
Acrylic on Canvas
34" x 40"

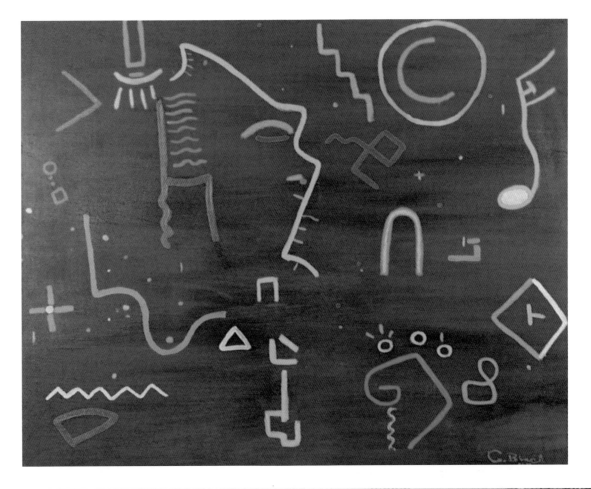

21. *The Migration*
1994
Acrylic and
Blown Powdered Pigment
38" x 52"

Mary Burke

"My interest lies in playing with formal elements of design. In some of the paintings, a grid-like composition forms the underlying basis for relationships between color, pattern, texture, line and form. In other works, these elements are free floating. I enjoy creating spacial tension through the use of value and the mix of dimensional objects in flat space. These objects usually have geometrical or natural significance. They invite the viewer to peruse the surface and create associations on various levels. I am quite analytical in my playful search for answers to the compositional puzzles that I have created."

22. *Science Project*
1995
Acrylic on Canvas
32" x 32"

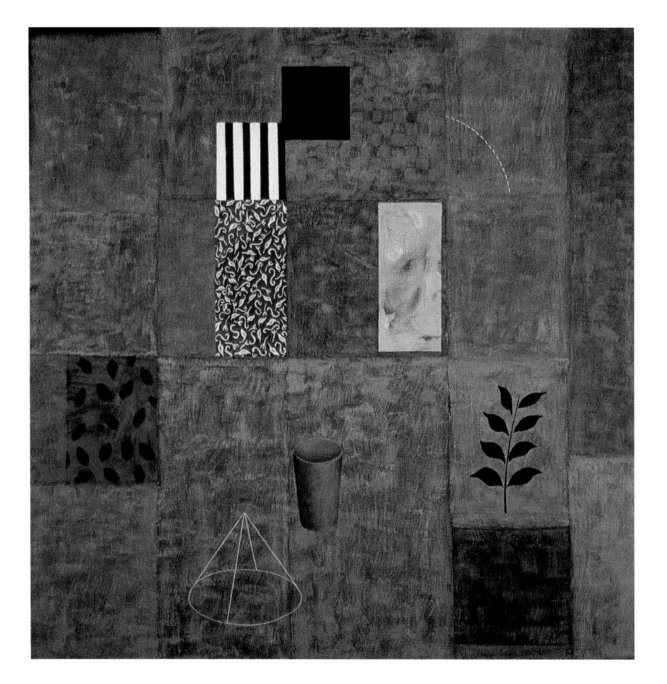

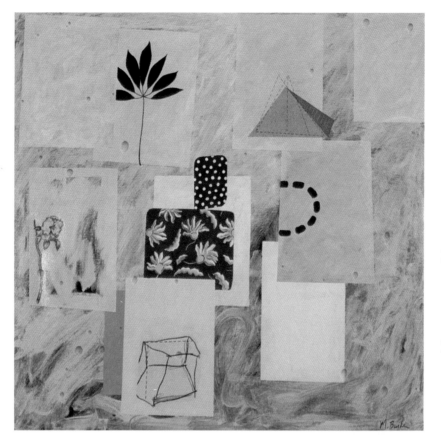

23. (left, top)
Postcards
1998
Acrylic on Canvas
30" x 30"

24. (left, bottom)
Grey Horse
1996
Acrylic on Canvas
36" x 30"

BIOGRAPHY

Burke received her Bachelor of Arts degree from University of Chicago and her Master of Fine Arts in Painting and Drawing from University of Minnesota.

She has had solo exhibitions at the Artemesia Gallery in Chicago, the Federal Reserve Bank of Minneapolis, and the Daedalus Gallery and Coffman Union Gallery in Minneapolis. Her work has also been shown at Charles A. Wustum Museum of Fine Arts in Racine, Wisconsin; Mary Bell Gallery in Chicago; 1800 Clybourn Gallery in Chicago; Hinsdale Art Center; Noyes Cultural Center in Evanston; and Evanston Art Center. In 1994, she received the Juror's Choice Award at the 12th Biennial Exhibition of Evanston Art Center. She had also exhibited her work in Florence, Italy and Colombia, South America.

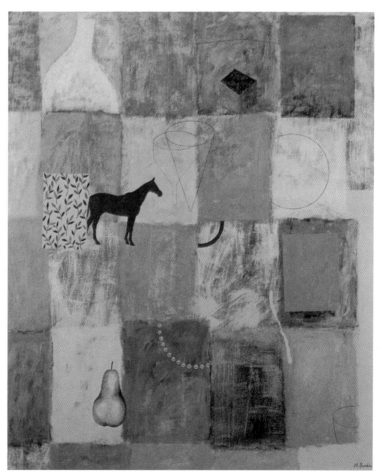

Rimas Ciurlionis

"Art is a means by which we can, for an instant, stop the mind or move it more forcefully in a direction to which we are unaccustomed. And that short journey from vision to creation is perhaps indeed the void through which it is possible to see signs.

In my work, I use signs and symbols and also common objects that surround us in our everyday lives. These I try to express in a symbolic meaning. Even abstract compositions are developed into symbols. In my art, I consciously try to concentrate the mind and emotion—in form, texture, color and line, which together form a symbol that can touch the mystery of existence."

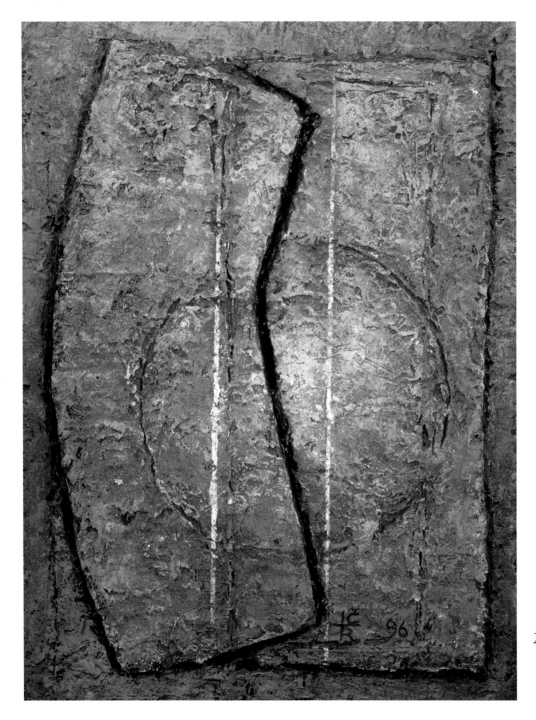

BIOGRAPHY

Ciurlionis was born in Kaunas, Lithuania. He studied painting and graphic arts while at the Stepas Zukas Art College. For eleven years after college, he was employed in the restoration of frescoes at the Pazaislis Monastery outside of Kaunas.

In 1982, he presented his first solo show at the Kaunas Drama Theater. A second was presented two years later at the Kaunas Architectural Society Gallery and a third in 1985 at the Kaunas Artists' Center. He also participated in a number of group exhibits in other Lithuanian cities.

In 1989, he was invited to Detmold, Germany where he presented an exhibit at the District Capitol. Later that year, he was awarded a residency at the Kunstlerhaus in Schwalenberg, Germany. While there, he took part in an artistic competition to commemorate the 800th year anniversary of the city of Lemgo in which he won the Second Place Award.

Ciurlionis currently resides in the Chicago area. He was an art conservator at the Chicago Conservation Center, and is now involved in private conservation in addition to his studio work.

25. *Red Circle*
1996
Oil on Canvas on Particle Board
11⅞" x 8⅜"

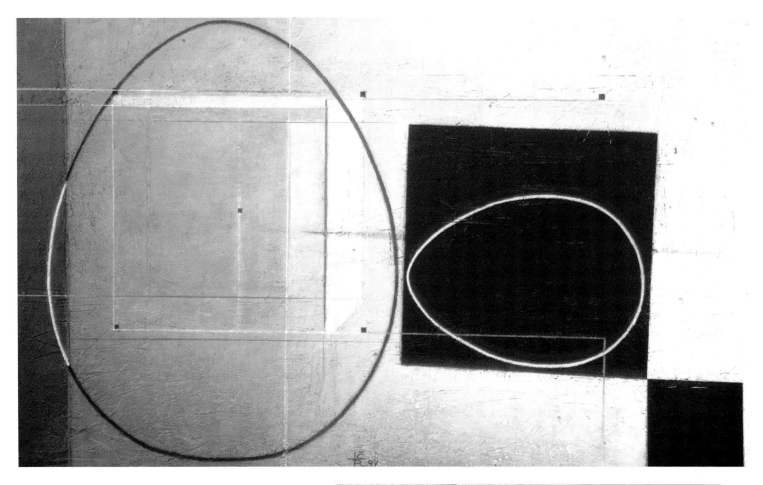

26. (above)
Balance of Forms
1997
Oil on Canvas
32" x 46"

27. (right)
Blue Square
1996
Oil on Masonite on Particle Board
20" x 19"

Locally, Ciurlionis has had solo exhibitions at the Lithuanian Museum of Art in Lemont, Illinois; the Balzekas Museum of Lithuanian Culture in Chicago; the First Unitarian Church Gallery in Hinsdale; the Riverside Arts Center; and the Loyola University Medical Center in Maywood. His work has also been shown at 'The Trickster' juried exhibit and Around the Coyote juried art competition in Chicago.

Peter Anthony Colón

"By definition, my work itself is very introspective yet communal. It focuses more so on the human condition than on anything else. Somewhat dark in nature, it seems to concentrate on the harsher realities of life. This makes it somewhat hard to swallow for some, but a shared secret to others.

It is simply what I see, what I know and most definitely what I am; and through it I reach out to others. Being one who stumbles on the spoken word, it is indeed my strongest form of communication and with it I shout out my humanity…my existence.

28. *Tainted Blue Placenta*
1997
Acrylic and Pastel
10" x 12"

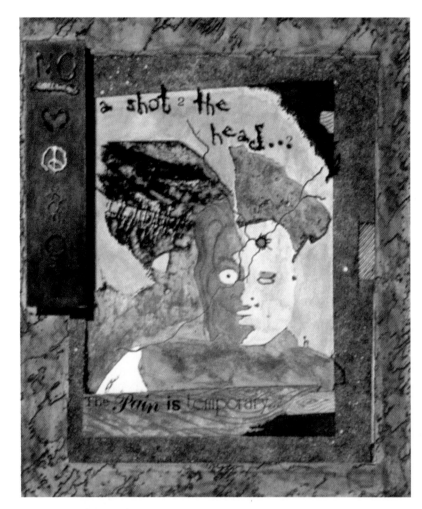

I enjoyed writing short stories and poetry—usually in the form of music lyrics. My work had always been very graphic. But it wasn't until my early college years that I began to incorporate visual elements into my literature.

It was actually a course in photography that first turned me on to the visual arts. Photography and painting quickly became my two favorite modes of expression. Most of my work is a mixture of all three of these mediums—painting, photography and literature."

BIOGRAPHY

Colón is a native of Gary, Indiana. He received his Bachelor's degree in Fine Arts from Indiana University in 1992. He has exhibited his work at The Gallery Northwest, Museum of Science & Industry-Hispanic Festival and ARC Gallery. His work has also been published in *Spirits Literary/Arts* Magazine.

29. (above)
 A Shot 2 The Head
 1994
 Watercolored Etching
 16" x 20"

30. (left)
 Drink Slowly
 1996
 Acrylic
 28" x 36"

Lois Coren

"I have always been fascinated by the culture, mores, and primarily the art of primitive peoples that we met on our travels in the Americas, Africa and New Guinea. They are the primary influence of my work.

At first I did totemic sculpture, adding to rather than taking away from the base. I was able to add all the fetishes, shamans, omens, symbols and personal shapes to my pieces, thus filling the forms with much texture and design. From free-standing sculpture, my work transferred to the wall and became mixed media reliefs or layered wall sculpture on framed wood. Today my work has evolved into paintings (gouache or acrylic forms) shaped with prismacolors and/or pastels and collaged with glass beads and sometimes grasses.

My work is drawn and formulated by the people, subjects and experiences of my life and it is painted with my emotions."

BIOGRAPHY

Coren studied at the School of the Art Institute of Chicago, the Evanston Art Center, and under Richard Loving (enameling) and Ruth Jennings (ceramics). She is a former board member of the Chicago Artists' Coalition and the Membership Chairwoman for the Primitive Arts Society. She is listed in *Who's Who of American Women 1997-1998*.

In 1982, Coren received the Hereward Lester Cooke Foundation Grant Award for Mid-Career Visual Artists. In 1990, she was nominated for Awards in the Visual Arts.

Coren's sculpture and paintings have been exhibited at numerous museums and art galleries, including the Fort Wayne Museum of Art in Indiana, Balzekas Museum in Chicago, Goldman-Kraft Gallery in Chicago, Blue Moon Gallery in Skokie, and Gallery Centre in Indianapolis. She is represented by Alter and Associates.

31. *4th of July*
1995
Mixed Media on Arches Collaged with Beads
38" x 30"

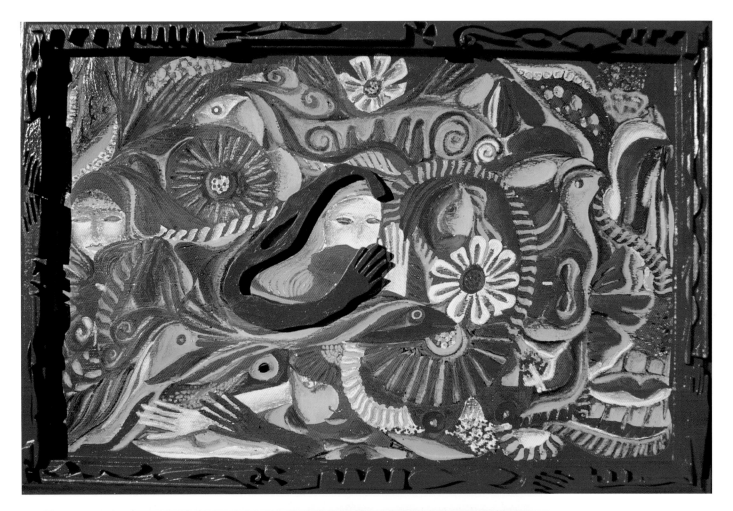

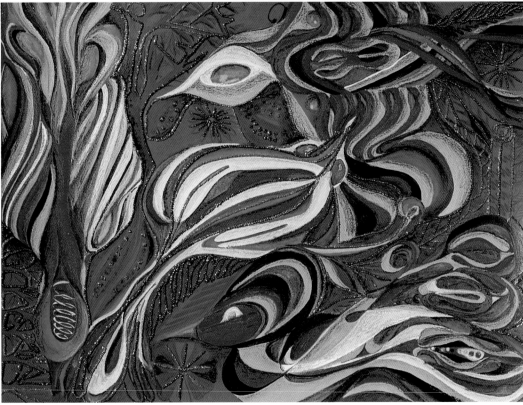

32. (above)
World Naivete
1997
Mixed Media on Wood
Collaged with Wood
with Hand-Made Frame
15½" x 23"

33. (left)
Night Flight
1997
Mixed Media Collaged with
Beads on Arches
38" x 30"

Bob Cosgrove

"I have been a graphic designer my whole working life. When I look at a canvas or piece of paper, I try to keep that in mind.

Most of my work is done from photos that I have taken; sometimes I might use something I saw in a magazine or newspaper, but not very often.

I try to compose a picture as I take the photo. That gives me the option to use the complete image or part of that image. Sometimes I see something in the photo print that I didn't see in the original. I can crop the photo anyway that I like. A small part of the photo may interest me. I have also used parts of the photos to make a collage.

I paint in acrylics on canvas, paper or board. You get a completely different reaction to the paint with the different surfaces. I like painting one color over another, letting colors show through. This gives an exciting effect that you can't plan on."

34. *Play at Home*
1997
Acrylic on Canvas
24" x 30"

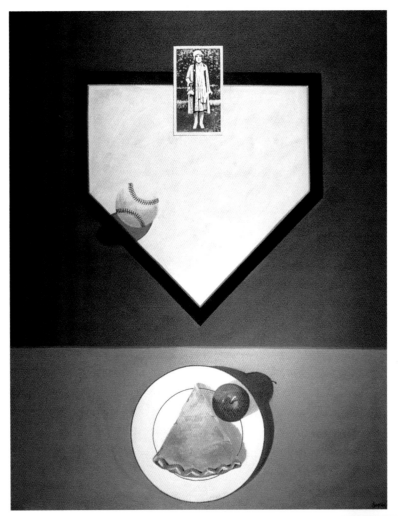

BIOGRAPHY

Cosgrove studied at the American Academy of Art in Chicago. He began his professional career as an artist in Chicago. He then worked in Louisville, Kentucky and Cincinnati, Ohio. He had his own graphic design firm in Cincinnati for many years before returning to Chicago in 1988. He received many awards in graphic design in the United States, and had exhibited in London and Zurich.

His paintings were exhibited in numerous shows in Cincinnati, including the Cincinnati Art Museum and the Contemporary Art Center. He was part of the Urban Wall show at Solway Gallery. The Urban Wall prints later became the permanent collection of the Cincinnati Art Museum and the Museum of Modern Art in New York.

Since returning to Chicago, Cosgrove has exhibited at the Wood Street Gallery; Riverside Arts Center; Triangle Gallery of Old Town; Center for the Arts in Michigan City, Indiana; and Kishwaukee College Art Gallery in Malta, Illinois among others.

35. (left)
Baseball, Mom, etc.
1995
Acrylic on Canvas
24" x 30"

36. (right)
Softball Bats
1997
Acrylic on Canvas
24" x 24"

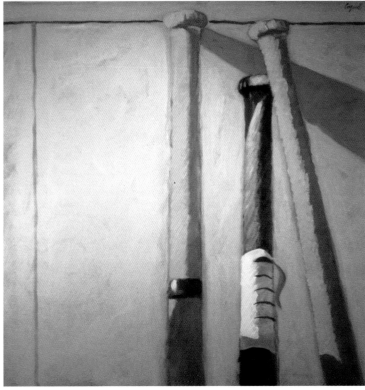

Mary Reed Daniel

"I have many themes in my work. I am presently concerned with capturing the wealth of images found in the urban environment. In particular, the African-American culture contains a reservoir of information I portray in my work."

BIOGRAPHY

Daniel was born in St. Louis, Illinois and attended Southern Illinois University. She is a Chicago artist with an international reputation, and is a frequent recipient of local and international awards and prizes. Her work is widely collected and can be found in many corporate and private collections, including the Chicago Urban League and the Smithsonian Institute.

She has permanent exhibitions at the Terra Museum, the Art Institute of Chicago, Howard University and the Smithsonian Institute, just to name a few.

Daniel's work has been published in numerous art magazines, books and other art-related periodicals. Recent publications include *The Art of Black American Women—Works of Twenty-Four Artists of the Twentieth Century* (1993) and *Gumbo Ya Ya: Anthology of Contemporary African-American Women Artists* (1995).

Her recent exhibits include The National Black Arts Festival Invitational at Nexus Contemporary Arts Center; American Consulate General's Commercial Section in Paris and Amsterdam; International Home Furnishings Market in North Carolina; and National Museum of Afro-American Art.

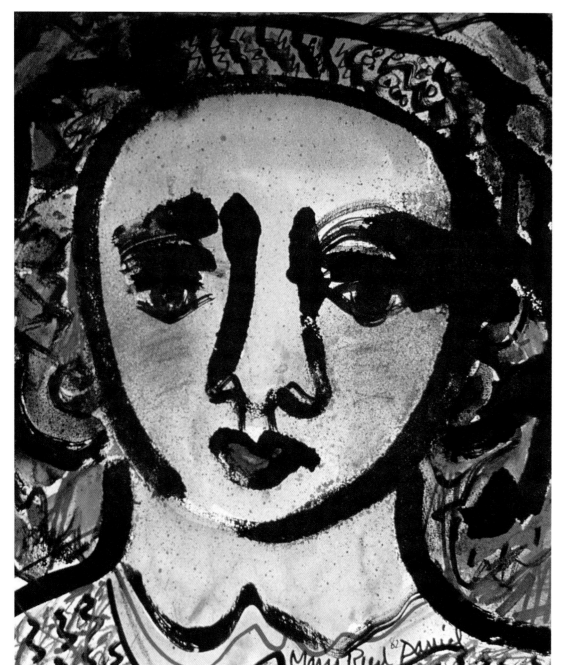

37. *Alma*
1992
Monotype with Oil Pastel and Watercolor
17" x 12"
Private Collection

38. (top)
Urban Landscape
1991
Acrylic, Oil Pastel
and Watercolor
24" x 19"

39. (bottom)
Floral Landscape
1997
Acrylic, Oil Pastel
and Watercolor on
Monotype
20" x 24"

Sharon DeLaCruz

"These fiber graphic quilts are original artworks created in mixed media (ink, watercolor and marbling). The original art is printed onto 100% cotton fabrics and sewn into quilts ranging in sizes from 18" x 24" to mural dimensions."

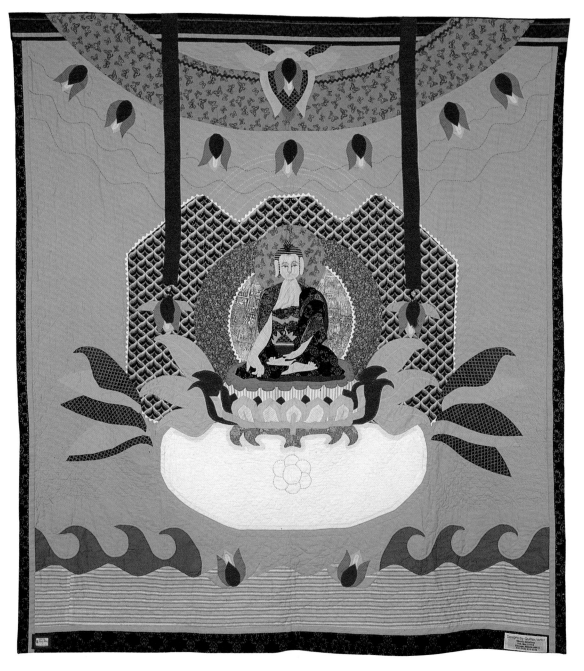

40. *Buddha Quilt*
 1998
 Quilt
 95" x 86"

BIOGRAPHY
DeLaCruz was born in Honolulu, Hawaii. She studied Graphic Design and Fine Arts at Washington State University; Medbargarskolan po Tecknar Swedish Art Academy in Maimo, Sweden; and Privat Kunst Studerier med Tjeerd Ackema in Amsterdam, The Netherlands. Her quilts are featured annually in the Annual Quilt/Fiber Arts Exhibition at the Chicago Botanic Gardens.

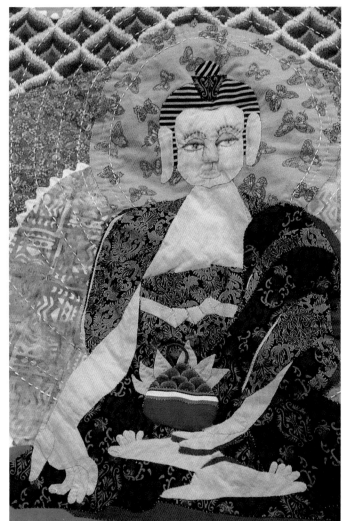

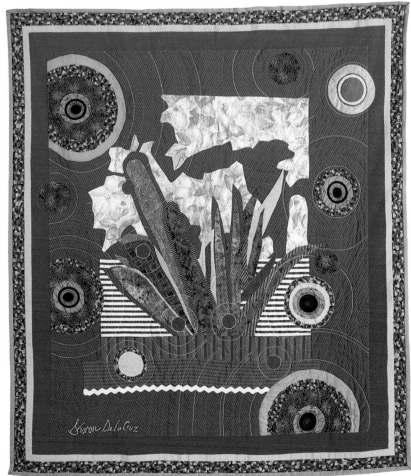

41. (above, left)
Buddha Quilt, Detail

42. (above, right)
Zen Garden II
1998
Quilt
76" x 68"

43. (right)
Zen Garden I
Detail of a quilt in the
Zen Garden series

Ascha Kells Drake

"I have been thinking about skin, the human senses, and the transformation of the human body in relation to our current culture. The skin is the boundary between the outside and the inside worlds, acting as a map of events the duration of life has manipulated, added and subtracted. Through the means of Japanese rice paper, fabric, cotton, thread, latex, pigment, beeswax and wood, I have been making pieces that capture an internal light, while emanating a glow that fills a space through the translucent veil of paper and fabric. By min-

imizing artistic means to only a few elements, I attempt to slow down the viewer's perception and thought. Radioactive yellow luminosity, tight, taut, sticky smooth surfaces, suffocating the senses in a visceral and tactile engagement, beeswax covered lozenge shapes hovering together on a white wall, quilted paper forms dissolving, cocoon beds resonating closeness.

Body meets body.

In reducing, I intend to create a state of being for the viewer; a meditative environment constructed within a world that has potential to render our bodies increasingly obsolete and digitalized. The world is generating things that have the power to remove a person from a physical existence to a metaphysical reality with an altered perspective. Technology has the potential to obliterate the needs for physical strength or muscular exertion. We are in a state of distraction where human perception is being retrained and human consciousness is moving farther and farther away from the natural 'real' world.

Severed bodies. Spatial bodies. Carving up the body's space. Dismemberment of the body. Overstimulated bodies. Contained bodies. The desire to touch something that relates to one's own body is vital. The desire to touch another body is vital. In essence, an invasion of the body is occurring as our lifestyles are being equipped with machines and micro-machines that can efficiently stimulate our faculties. The forms I create are to be seductive through their glow, their surface, their curvaceousness, their tactility. As technology transforms the human form's natural network of fibers into a machine, I wonder what history we are leaving behind. Electronic footprints are hard to follow, and I have no desire to be plugged into a virtual system of synthetic realities, where real time is replaced by dreamy nontime/indistinguishable time."

44. *Flight*
1997
Charcoal, Shellac, Gesso, Ink and
Pencil on Paper
50" x 38"

BIOGRAPHY
Drake double majored in Studio Art and Art Education at Skidmore College in Saratoga Springs, New York and received her Master of Fine Arts in Printmaking from Cranbrook Academy of Art in Bloomfield, Michigan.

Drake taught basic drawing to 10-14 year olds, and held an exploration class with kindergartners at Paint Creek Center for the Arts in Rochester, Michigan. She was awarded the Pamela Weidenman Award for her printmaking and the Jesse Soloman Prize for her painting.

Drake was born in Chicago and lived here during her childhood. Since her return to Chicago, she is working out of her home and using the facilities at the Chicago Printmakers Collaborative in Wicker Park. She is presently focusing on fabric and paper, quilting and hand sewing hand made patterns and forms which she then photographs and manipulates through the processes of photography, film and printmaking.

45. (above)
Suspension
1997
Pigment, Shellac and Ink on Paper
50" x 38"

46. (right)
Untitled
1998
Lithography, Beeswax and Collage on Paper
48" x 34"

Beverly Ellstrand

"I usually work in series, but sometimes my work reflects a reaction to an important event or an emotional response and personal opinion about some aspect of society. Recently I have been doing work that addresses the problems of the environment.

In *Color Bars*, the two women in the painting are shown with their hands linked in mutual interests and admiration. The women grew out of the natural forms from the world of nature that links all humanity together. The large leaves symbolize the oneness of all, regardless of our differences. The roots dig deep into our society proclaiming there are no color bars.

Environmental Fallout addresses the destructiveness of environmental pollution and was included in a large exhibition at DePaul University entitled 'Apocalypse—Now and Then: Art and the End of Time'.

The End of Evolution? also addresses the problems of pollution on our planet. Using the symbols and vocabulary of the Botanist through the drawings of leaf forms, plant structures, zygotes and cell structures to signify the destructive forces of pollution, the world is depicted in darkness. The colors used give an unreal feeling to the painting."

BIOGRAPHY

Ellstrand was educated at Northeastern University in Chicago and the Chicago Academy of Fine Arts, and had taken Master Workshops for Teachers at The School of the Art Institute of Chicago from 1985 to 1996.

Ellstrand has been teaching Basic Drawing, Painting and Art Appreciation Seminars at Suburban Fine Arts Center in Highland Park for 15 years. Previously, she also taught at the Oakton Community College in Skokie. She recently had solo exhibitions at Wood Street Gallery, Chicago; Vissi D'Arte Gallery, Wilmette; and Old Town Triangle Art Center, Chicago.

In 1995, Ellstrand curated the mid-century exhibition of members of the Chicago Society of Artists. She was a judge for the Area Three art competition for the City of Chicago. Her work was included in numerous publications including *Arts in the Parks*, a State of Illinois publication (July/August 1997 issue), and *Norway News*, a Norwegian Embassy publication (May 1997 issue).

47. (above)
Color Bars
1990
Watercolor and Pencil
28" x 22"

48. (opposite top)
Environmental Fallout
1997
Colored Pencil on Watercolor
22" x 28"

49. (opposite bottom)
The End of Evolution?
1998
Colored Pencil on Watercolor
22" x 28"

Jason Fairchild

"My paintings are free-form theatre. They are about elegance and obsession with intensity—rising seas, blowing fields and the silver screen, and are narrative expressions of our unsettled, spectacular, contemporary culture. I want my work to spark varied interpretations and numerous associations which allow

50. *Destroying the Temple*
1996
Oil on Canvas
132" x 96"

memories and questions to flow. These works suggest metonymic self-portraits, masonic and sexual motifs and homages to artists and the artist's model. Through projections and screens of overlapping metaphors and color schemes, the female figure becomes the star. My paintings are not about exploitation, but about life, with its good and evil, tragedies and triumphs."

BIOGRAPHY

Fairchild was born in Niles, Ohio. After studying art and illustration at Ohio State University, he moved to Chicago where he left a career in medical illustration to further his fine art work. He has several exhibitions scheduled for 1998, including solo exhibitions at SAI Gallery in New York and The Furnace Gallery in Chicago.

51. (above)
Justice
1996
Oil on Canvas
46" x 40"

52. (right)
Untitled
1996
Oil on Linen
70" x 48"

Sheila Finnigan

"Approaching the Millennium, I bring to the canvas a return to powerful emotion. My work brings into focus both past and present, each reflecting the other. Contemporary politicians, movie stars and Holocaust victims stand on the same narrative plane with figures from 'lost' civilizations, such as Aztec and Egyptian. The arrangements of the figures, their raw colors and their shapes emerging from the darkness, suggest that they are searching for a meaning which eludes them.

My paintings say much about darkness: the dark side of civilization, the darkness through which we 'parade', and the darkness of our ideas—ideas which seem at first to illuminate, as the touches of color in my paintings, and at last to confound and defeat us. The color white represents hope, but the comparative lack of that color in my work is intended to suggest we remain unenlightened.

53. *Dark Century: The Journey*
1995
Mixed Media on Paper
42" x 54"

All mixed media works shown include tempera, oil, oil pastel, ink and acrylic.

A strong element in my work is the use of anachronism, which sometimes borders on dark humor. Also, I portray women in important roles. For example, in *Pop!* Marilyn and Jackie pull equally with Joyce, Freud, Einstein and Holocaust victims on the 'umbilical cord' that binds present with past.

In the *Study for 'The Re-Invention of the Wheel'*, a female figure in the left panel stands on a clown whose gaiety has vanished like our vanishing ideals. In the right panel, a second clown beckons a woman to take up the mantle of her ancient calling and 're-invent the wheel', providing society once again, as in the dim past, with heart and purpose."

54. (opposite, above)
Study for 'The Re-Invention of the Wheel'
1998
Mixed Media on Paper
39" x 53" (Diptych)

55. (opposite, below)
Pop!
1997
Mixed Media and Glitter on Stretched Paper
75" x 84" (Diptych)

BIOGRAPHY

Finnigan has had numerous solo exhibits at ARC Gallery, Chicago in past years. In 1997 alone, she was selected for the 1997 Area Invitational at Aurora University Art Gallery, the Eight-State Regional Exhibition at ARC Gallery, and the 25th Anniversary Exhibition of Women's Caucus for Art entitled 'Carving the Forces of Change'. In 1998, she was selected as one of 32 artists out of 1,400 submissions to be in the Hunter Museum of American Art exhibit in Chattanooga, Tennessee.

Finnigan has received many awards and prizes for her work, and was featured in newspapers and magazines. Her work was included in the Midwest edition of *New American Paintings* magazine in August, 1997.

Judith Roston Freilich

"As I look back at the progression of my work, it becomes obvious to me that what excites us changes very little as years pass, and the experiences and ideas that we bring to our early passions continually enrich and deepen our lives. Drawings map our experiences, ideas and feelings on life's journey, making both continuity and change.

On this journey, we're aware of the surprises and incongruities in life—some amusing, others threatening. For me, they appear spontaneously as I draw. From plant life and a few unrelated organisms, a continuing story develops in my mind that I can see very clearly. All the images you see are 'real' in my mind and tell stories of a moment in time. They are stories of a fanciful world of infinite space and time which are cyclical in nature, not unlike the story of all living things. The world in each of these stories is full of contradictions. It bursts with energy and swells with tranquillity—slow transitions and frenetic, chaotic interruptions. The predictable structure and distinct rhythms are inevitably disrupted with random surprises that mystify all of us. In each of these stories, something can usually be found that holds these often disjointed microcosms together.

Exploring the potentials of different media plays an important part in conveying the characteristics of my images. The textures and the line qualities which are inherent in the various media reflect the unique nature of each image. Gesso, built up under some drawings and on top of other drawings, results in diverse textures. The possibilities that graphite, pastels, watercolors, colored pencils and oil crayons present as they interact with each other offer endless discoveries. Although the media seems to take on its own life, it is important to remember that it is secondary to each story of a moment in time."

56. *Untitled II*
1997
Mixed Media
40" x 30"

BIOGRAPHY

Freilich received her Master's degree in Printmaking under Misch Kohn at the Illinois Institute of Technology and has studied at the School of the Art Institute of Chicago. Her work is in the permanent collection of the Library of Congress, the First National Bank of Chicago and Southern Illinois University. She has had solo exhibitions at the Illinois Arts Council, Ohio State University and The Ann Brierly Gallery at New Trier High School. She was the curator of prints at Landfall Press, Chicago and has taught in the classroom and at art workshops for both young children and high school students.

57. (right)
Untitled 1620
1997
Mixed Media
10" x 14"

58. (below)
Interrupted Rhythms 11200
1997
Mixed Media,
Gesso on Paper
30" x 40"

51

Walter A. Fydryck

"I have established an approach to drawing that examines the related emotional response amongst a grouping of people. This is further emphasized by subtle details. I use a photo process paper as a base and apply a color wash in a controlled manner which creates a frottage-like surface. I then use a very fine black pencil to delineate the forms and facial features. Colored pencil is then applied over the base wash and accentuates the inherent textural qualities of the wash. Volume is created by shading, and color selection establishes the emotional content of the drawing.

59. *Group Reaction*
1997
Colored Pencil over Ink Wash
on Photo Process Paper
19¼" x 23½"

I have always been interested in unconventional approaches. This somewhat began with the advent of Rock-n-Roll. Witnessing the birth of a new attitude led me to explore its roots: jazz, blues and country. Seeing how it all was first put together influenced my approach to art. I purposely combine different techniques, forcing myself to come up with something special which allow the techniques to work together.

I am also influenced by the 'pop' side of photography. I have had the opportunity to work with photographers such as Avedon and Skrebneski and I was always impressed by how their studio problem solving led to the look of their final photos. I also employ this approach in the development of various techniques.

Finally, I have also been influenced by work that has a strong ethnic tradition."

BIOGRAPHY

Fydryck studied at the School of the Art Institute of Chicago and the American Academy of Fine Art.

Fydryck's work has been exhibited widely over the years. In 1997 alone, Fydryck had one solo exhibition at Anatomically Correct/Straw Dog Theatre, and sixteen group exhibitions, including the Twenty-First Annual Alice and Arthur Baer Art Competition and Exhibition at Beverly Art Center; Polish Arts Club 63rd Annual Exhibition of Painting and Sculpture; 47th Annual Quad-State Exhibition at Quincy Art Center; Art In The Woods 14th Annual Exhibition at Corp. Woods Gallery in Overland Park, Kansas; and an invitation from Slowinski Gallery in Soho, New York to participate in Art Web (http://www.slowart.com/artweb).

Fydryck was invited to participate in Art Against Aids from 1994 through 1997.

60. (right)
The Decision
1997
Colored Pencil over Ink Wash
on Photo Process Paper
17½" x 23½"

61. (below, right)
Hot Steamy Night
1995
Colored Pencil over Ink Wash
on Photo Process Paper
17¾" x 23¼"

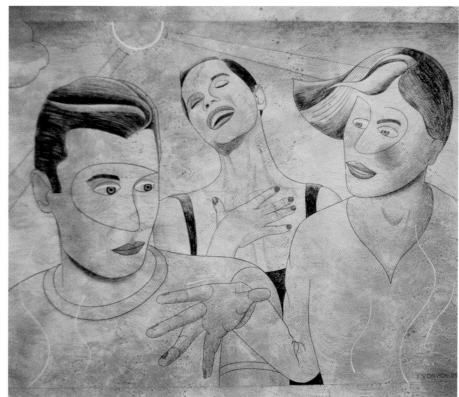

Maria Gedroc

"My paintings celebrate the spirit and inner beauty of the seemingly commonplace urban environment. The urban environment includes the large metropolitan area as well as small neighborhoods that surround it. The content of these paintings is influenced by my love for architecture, old and new, and the beautiful shapes and colors that emerge from it when contrasted by its natural and man-made surroundings.

Through the use of architectural elements such as a door or a window, these paintings tell the story of who we are and how and where we live and work. People are sometimes included, but it is mostly the details of the building that are used to tell a story. The story is whatever you, the viewer, want to see and imagine. What neighborhood do you live in? What is the history of the neighborhood? Do you have special memories of a certain neighborhood? Look at the buildings closely and you will see that they have a history and a life of their own.

I hope that after seeing these paintings you have a better appreciation for the buildings in your neighborhood. Take a closer look at the colors and patterns in wood, brick, glass or other materials. What may seem to be an old rusted building at first glance can be transformed into beautiful shades of color and texture. Or what may seem to be a simple glass window actually shows us colors and shapes through its reflections. This is what I see when I look at buildings. I hope you can see it too."

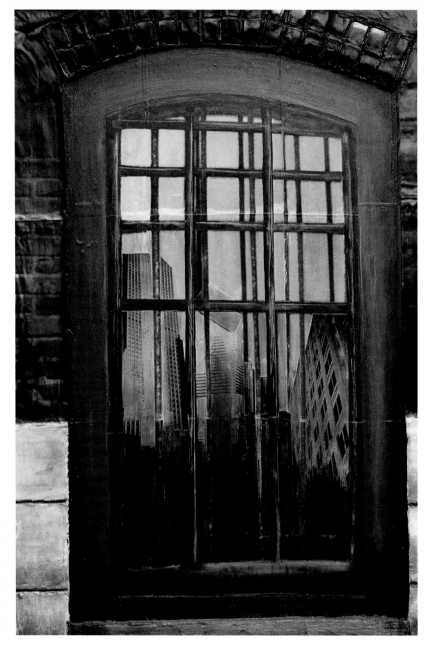

62. *City Scape*
1997
Acrylic, Paper and Spackle
60" x 48"

63. (right)
The Flowers
1996
Acrylic, Paper and Spackle
34" x 24"

64. (below)
Vesuvio Bakery
1996
Acrylic, Paper and Spackle
34" x 24"

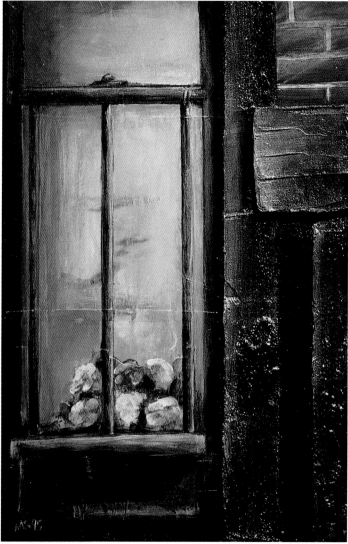

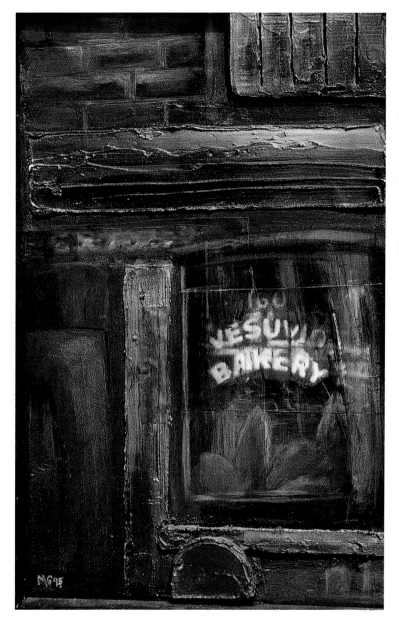

BIOGRAPHY

Gedroc received her Master of Art Administration degree from The School of the Art Institute of Chicago in 1995. She has worked with various companies and newspapers in graphic design, marketing and production on a freelance basis and otherwise. She is also active in volunteering her services for many organizations, including the Arts and Business Council of Chicago, Association of Corporate Art Curators, City Arts Panel, Chicago Artists' Coalition and New Chicago Artists. Since 1995, she has had annual showings at Around The Coyote in Wicker Park, Chicago.

Mary Barnes Gingrich

"While painting portraits, I share an intimacy with the subject that helps depict the subject's spiritual as well as physical qualities. Human potential is emphasized by painting the subject larger than life. Women and children are my favorite subjects. Their dignity, often ignored by painters of previous centuries, dominates each work. Genre painting, which may include more than one figure, adds an intriguing narrative quality. It is essential to strive for strong composition—the foundation that supports the content of a piece. Each portrait is a complicated drama that continues to unfold throughout its execution."

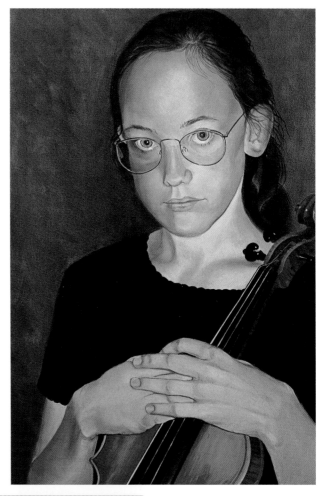

65. (right)
Girl with a Violin
1997
Oil on Canvas
36" x 24"

66. (below)
Backgammon
1997
Oil on Canvas
30" x 40"

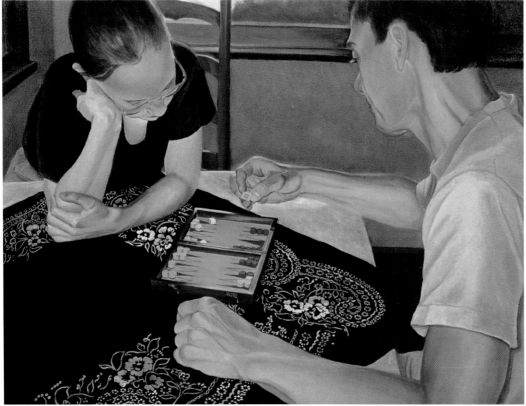

BIOGRAPHY

Gingrich was born in Chicago, raised in Glenview and has resided in Wilmette since 1978. Art and music have played important roles in her life since childhood. She received a degree in Music Performance from Northwestern University. While at Northwestern, she also pursued her interest in art, with a focus on art history. Since that time, she has continuously studied both art forms. Her artwork was exhibited in local and national juried shows such as the 1995 Art of Diversity and the 1996 National Small Works Show both at An Art Place Gallery, Chicago; the 1995 Alice and Arthur Baer Competition at the Beverly Art Center; and the 1995 Midwest Print Show held at Loyola University in which she received an Award of Excellence. She had music performances with the Chicago Symphony and Lyric Opera of Chicago.

In 1997, Gingrich set aside her musical career to concentrate on art. She recently finished two and a half years of copying master paintings in the museum galleries of the Art Institute of Chicago.

Gingrich enjoys both painting and printing. She currently maintains Intermission Studio and Gallery in Evanston. Her artwork appears in private and corporate collections.

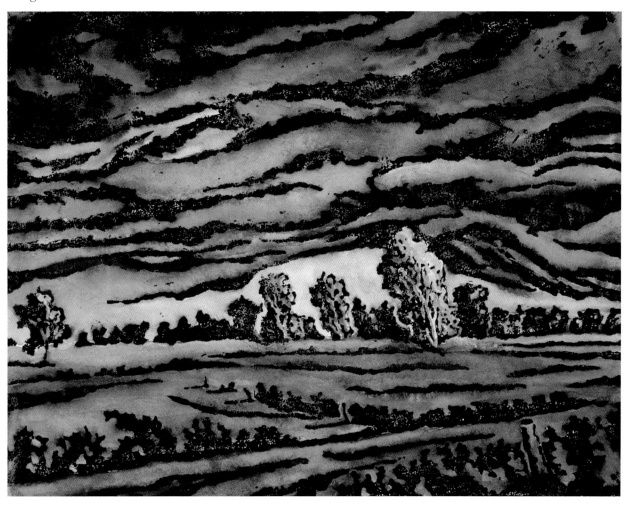

67. **Wind**
1996
Hand-Colored Print from Plaster Block
10" x 13"

"The landscape is a tangible reflection of our human existence. We yearn for its solidity and identify with its elements. Trees and plants dominate the terrain, buffeted by forces of nature, a metaphor for our journey through life. Light brings inspiration and direction, revealing God's omnipotent presence.

Working with plaster block prints began as a way to experiment freely with color since the hand-colored prints allow wide color variations of each landscape. This process has given definition and cohesiveness to my work, which is distinctly rooted in American tradition."

Michael J. Gould

"At the heart of my paintings lies a close relationship with the landscape.

Changes in weather, the passage of seasons and shifts of light are like fleeting expressions over a familiar face to which I respond on an emotional level. This response finds its embodiment in the color arrangements that arise through the act of painting.

It is my conscious intent to provide an uplifting visual experience for those, including myself, who view painting as a means to transcendent insight. My style is directed toward this end. I use simplified forms arranged within a shallow pictorial space, suspended within a border, and lyrical color to invoke the sense of otherworldliness and of the creative presence that underlies nature.

I offer my paintings as an invitation to join in the natural processes of creativity and to dwell in the heart of beauty."

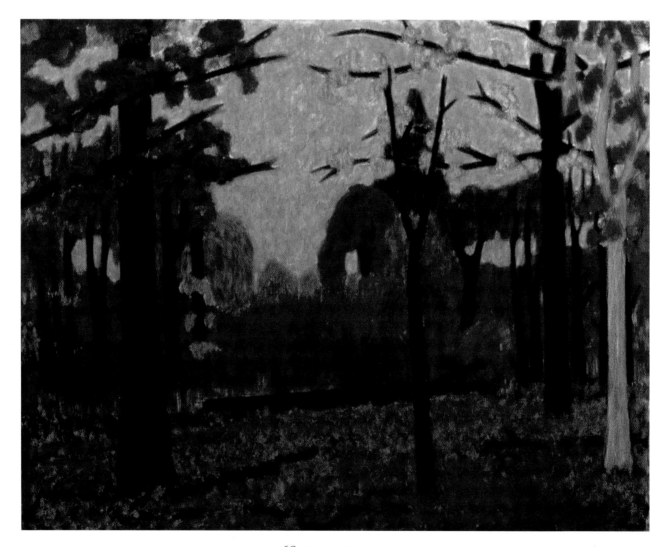

68. *Autumn Rain*
1996
Oil
38" x 48"

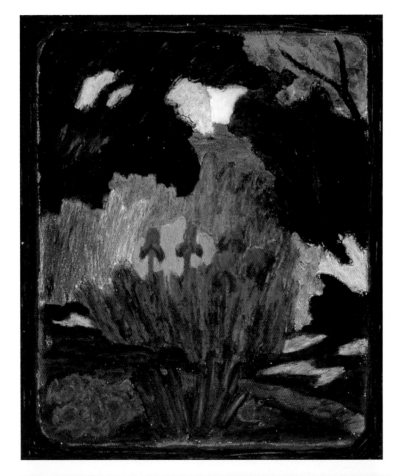

BIOGRAPHY
Gould was born in Chicago and raised in Northbrook. After earning his Master of Fine Arts in Painting from Southern Illinois University, he remained in southern Illinois to teach and paint landscape. Three years ago, he returned to Chicago to further his professional development.

Gould has exhibited widely over fifteen years. His paintings are included in numerous corporate, museum and private collections.

69. (right)
Irises
1996
Oil Pastel
12" x 10"

70. (below)
Frozen Pond
1997
Oil Pastel
10" x 12"

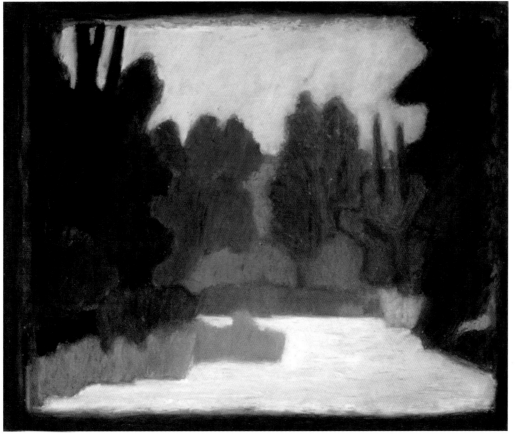

Jean Hirsch

"Landscape is my home, to be lived in and expressed. My paintings are metaphors and excitements, responses to very specific places. Working directly from a visual source, I try to find a dialogue between that place and my visual idea of it. That dialogue is observational, conceptual and expressive. Light, form, intuition and indivisible space combine to form the final unison. I strongly feel that all landscape is built from the same elements: light, color, form, space, state of mind and place. I see rhythm and strength in the land. All this excites me. I hope to translate that excitement to the picture plane and share it with others.

My paintings explore the relationship between abstraction and realism. To me, abstraction is an action or thought in time which are 'inherent properties of the actual physical object or concept' and can be accessed and used as a point of departure for investigation. Realism is the objective visual truth. Both are seen as a process of discovery, existing in the continuum of time. In particular, abstraction is a continuum which allows objective reality to travel a path of exploration which becomes so specific and so universal that inherent abstract qualities become real, the objective becomes subjective and reality takes on a new, more immediate quality. My paintings want to hover in the junction between these two identical, mirrored yet contradictory visions."

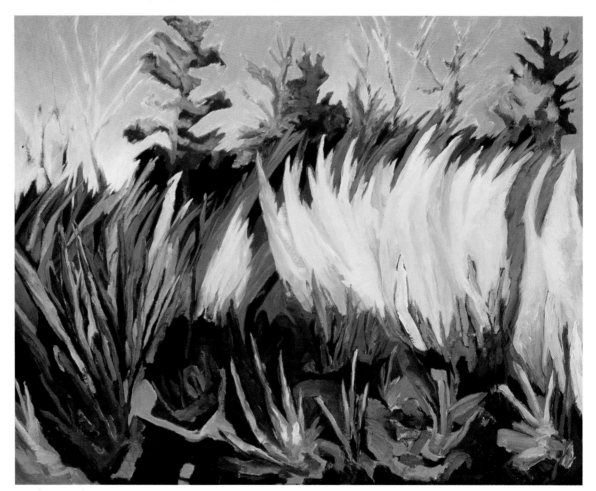

71. (above)
Carnival
1997
Oil on Canvas
20" x 24"

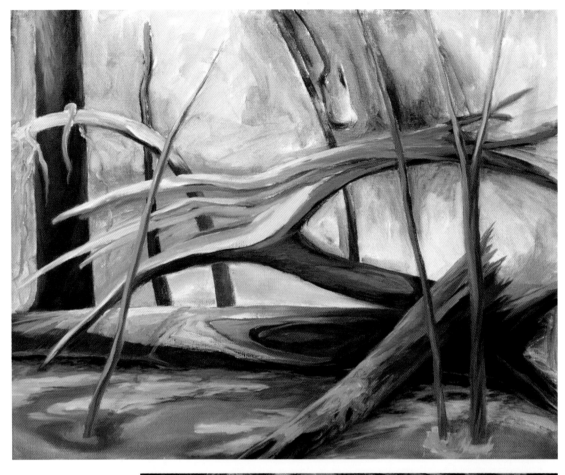

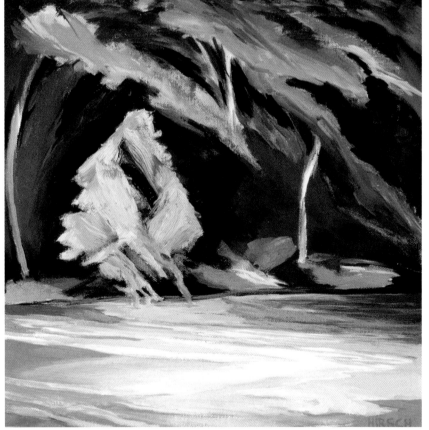

72. (above)
Storm Tree
1997
Oil on Canvas
16" x 20"

73. (right)
Whisper Tree
1996
Oil on Canvas
12" x 12"

BIOGRAPHY

Hirsch was born in Detroit, Michigan and has taught art in Ann Arbor for a number of years. She received her Bachelor of Fine Arts in Painting from University of Michigan, specializing in Multi-level Art Education. She has attended seminars at various locations including the Vermont Studio School in Johnson, Vermont; the Yale University School of Art in New Haven, Connecticut; Instituto de Allende in San Miguel de Allende, Mexico; and Ox-bow Summer Studio School, School of the Art Institute of Chicago in Saugatuck, Michigan. For the last twenty years, she has lived in the Chicago area with extended stays in Bloomington, Indiana; Palo Alto, California; and Tucson, Arizona. She is currently a faculty member of the Evanston Art Center, teaching Basic Drawing and Multi-level Watercolor.

Hirsch's work has been exhibited in galleries and museums around the country. In the last two years, her work was shown at the Downey Museum of Art in Downey, California; the Twelfth Annual Greater Midwest International Exhibition at Art Center Gallery of Central Missouri State University in Warrensburg; the Marsh Art Gallery of University of Richmond in Virginia; and the Snowgrass Institute of Art in Cashmere, Washington. Here in Illinois, she has exhibited at Union Street Gallery in Chicago Heights, Chicago Botanic Garden in Glencoe, and at Gwenda Jay Gallery, An Art Place Gallery and Woman Made Gallery in Chicago.

J. Allen Hyde

"My greatest inspiration to become an artist came from my mother. As a youngster, I witnessed a drawing produced by a younger classmate. I immediately returned home and asked my mother to teach me to draw. She then taught me a simple line drawing which led me to enroll in every art class that particular school offered.

I am driven to produce work of great resourcefulness, science fiction surrealism and individual vision. My wish is to reach the largest audience possible without compromising my personal technique or convictions. A fine line exists between developing a visual language accessible to the public and creating a kind of deep personal imaginary that relates to life. I want to illustrate my concern with the effect of robotic technology, kinesiology and the human anatomy in modern and future life. I also want to examine the tension between the natural, man-made and often satirical reactions to new age or pop culture. It carries you beyond the system, beyond the common place and surpasses all expectations. Nonetheless, my art is an element of familiarity."

BIOGRAPHY
Hyde studied art at Dillard University in New Orleans, Louisiana and at the American Academy of Fine Arts in Chicago. In the 1994-1995 Black Creativity Exhibition at the Museum of Science & Industry in Chicago, he won Honorable Mention for his work. He has had various art showings in the Midwest. In the last two years, his work was exhibited at Studio 702, Inc. in Chicago. He is currently a freelance artist.

74. *Bald Cypress Comment*
1995
Acrylic, Oil, Pen and Ink, Pencil
48" x 36"

75. (right)
Culdazac
1994
Acrylic, Oil, Pen
and Ink, Pencil
36" x 48"

76. (below)
See No
1994
Acrylic, Oil, Pen
and Ink, Pencil
36" x 48"

Margaret Derwent Ketcham

"I am an architect who has retired from the business of architecture to pursue a more artistic life. I have always loved to draw and paint.

I often paint compositions that I see while I am moving. I jot them down on whatever receipts I happen to have in my wallet, test them out in my sketchbook, and then paint some of them. During the fall of 1996, I taught an architecture design studio for fourth year design students at the University of Notre Dame in South Bend, Indiana. The class was three days a week and I commuted from Chicago on the South Shore train. The train travels through the industrial districts of Hammond and Gary, arriving at the South Bend airport. Due to the presence of airports in the industrial districts, there are many objects painted red and white, either in a checkerboard or striped pattern so that they stand out from their backgrounds so that the airplanes don't hit them. I find them to be very beautiful.

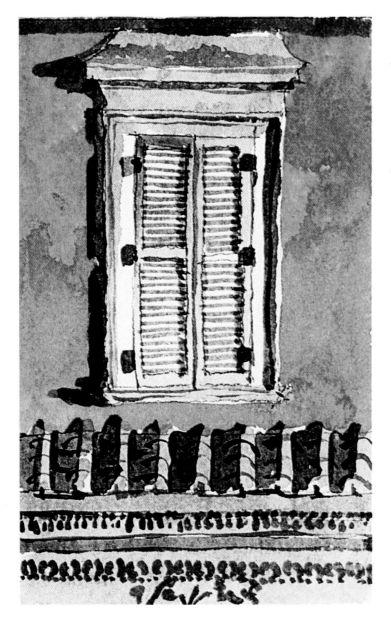

77. (left)
*Roof View IX
(Finestra)*
1996
Pencil, Watercolor
6.5" x 4.5"

78. (right)
*Airport
Checkerboard*
1997
Pencil, Watercolor
15" x 4.5"

I still love buildings themselves. But recently, I have joined a group that draws live from the nude figure on a weekly basis in Evanston. I find the body to be the ultimate challenge, especially after years of drawing buildings which have relatively simple and predictable shapes and shadows."

BIOGRAPHY

Ketcham grew up in South Bend, Indiana and attended the University of Notre Dame. She has worked as an architect for twelve years at Booth/Hansen & Associates in Chicago, and has taught architectural design and drawing to both high school and college age students at the University of Notre Dame. Her work was exhibited at the Chicago Athenaeum and the Art Institute of Chicago in conjunction with Booth/Hansen & Associates, and her travel sketches were exhibited in the I-Space Gallery with the Chicago Architecture Club.

79. (left)
Farm Windows
1996
Pencil, Watercolor
15" x 4.5"

80. (below)
Ann Odalisque
1997
Graphite
18" x 24"

Jill King

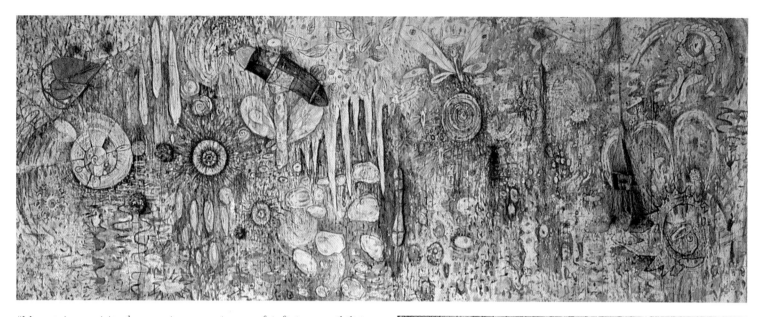

"My art is a spiritual quest into a universe of infinite possibilities, emerging from the fusion of drawing, painting, constructing and revealing. I strive to capture my desire for simplicity through building up fields of swarming complexities. I call these paintings 'self-reproducing life patterns'. They are inspired by my experiences with nature and the nature of my experiences. For me, they are entries into the dimensions of my soul. They are paintings that give form to the intangibles: love, hope, promise and being."

81. (above)
Dance of Dreams
1996
Installation: Acrylics, Inks and Wood on Muslin
9' x 24'

82. (right)
Dance of Dreams, Detail

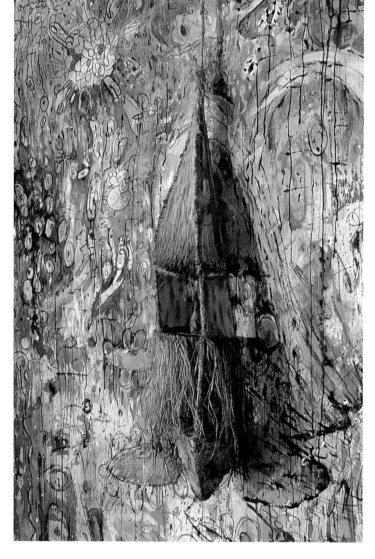

BIOGRAPHY

King was born in Chicago and has been working as a professional artist for over 15 years. She presently resides in Evanston and maintains her studio in Rogers Park. Her academic credentials include a Master of Arts in Painting from the University of Wisconsin-Milwaukee and a Bachelor of Fine Arts in Sculpture from Northern Illinois University. She has taught courses in Art Fundamentals, Illustration and Life Drawing at the American Academy of Art in Chicago from 1991 to 1995.

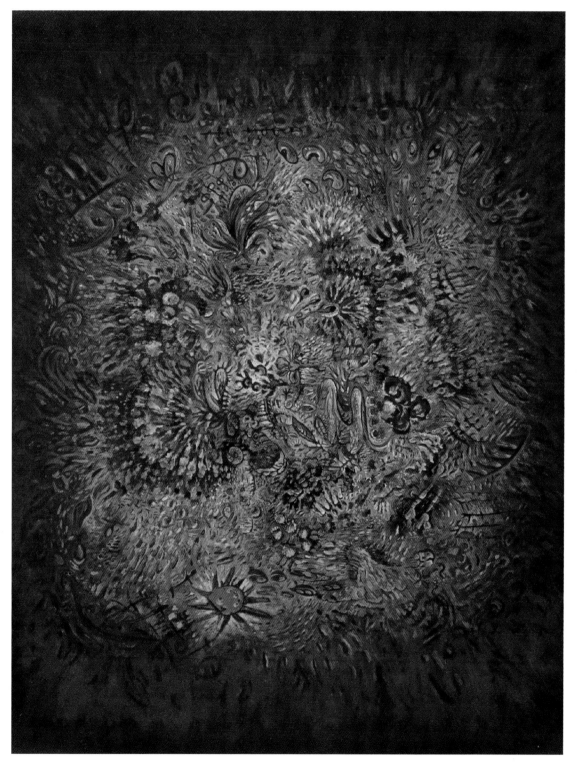

King serves as a creative mentor to adults, children and the elderly at local art and community centers. She works as a freelance artist in design, illustration, packaging and exhibition, and her commissioned work included large-scale mural and faux finish effects for retailers in Arlington Heights and Palatine; highly rendered pencil drawings of prehistoric animals for Encyclopædia Britannica; and the construction of life-size fiberglass trees for the 'Habitat Africa' exhibit at the Brookfield Zoo.

Her work has been in both solo and group exhibitions, including the Milwaukee Art Museum; the Burpee Art Museum in Rockford, Illinois; Wright Museum of Art in Beloit, Wisconsin; and many galleries in the area.

83. *The Unfolding*
1995
Oil on Linen
68" x 56"

Eric Koelle

"My watercolor is about capturing some of the natural beauty that can be found inherently within any subject. I have been influenced by Joyce Kitchell who is a watercolor illustrator in California. She inspired me to paint loose, giving the painting that wet, fresh feel."

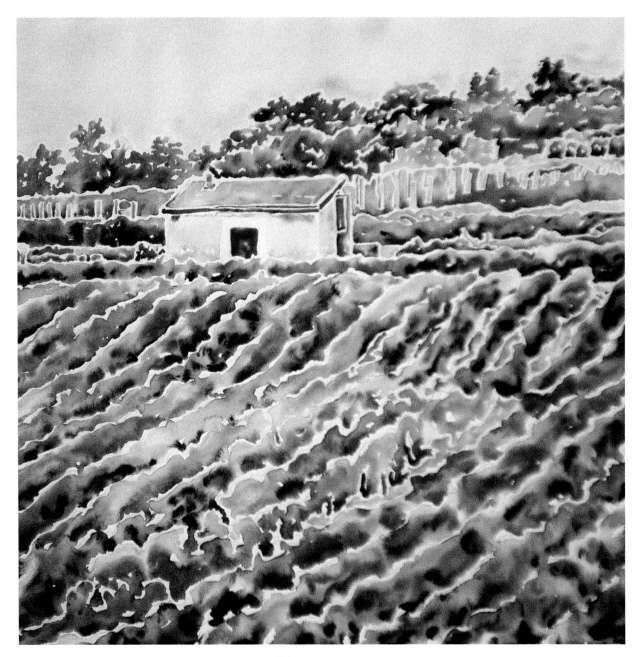

84. *Italian Vineyard*
1997
Watercolor
22" x 22"

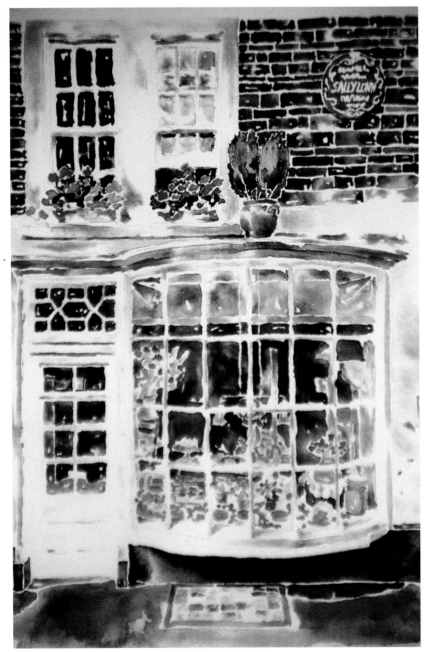

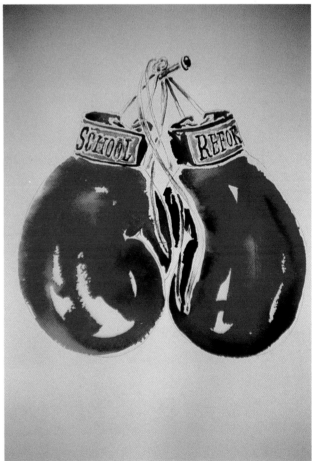

BIOGRAPHY

Koelle grew up in Glencoe, Illinois, and had two years of college before he knew he wanted to be in a creative field. With the help of his father, he secured a position as an art director in an advertising firm. At the urging of his family, he then started pursuing a career in watercolor.

Koelle has participated in the Glencoe, Northfield and Wilmette Art Fairs since 1995. He had exhibited his work at the 'Amazing Lace' exhibit in Lake Bluff in 1996 and 'The Landmark of Andersonville' in 1997. He was hired by Alice Chrismer Design in Evanston to illustrate a ten-month newsletter for the Community Renewal Society and a brochure for the Presbyterian Homes in Lake Forest. His work was also selected to be in two 1998 calendars.

85. (above)
The Sally Lynn House,
Bath, England
1995
Watercolor
9" x 12"

86. (right)
School Reform
1997
Watercolor
8" x 10"

Deborah Maris Lader

"These images are part of a series that deals with the theme of healing. They are about my son Daniel who, now four, was diagnosed with mild autism. The hands in these works belong to the masseuse and embody the attempts we make at fixing, shaping, changing and touching. Hopefully these hands will get it right."

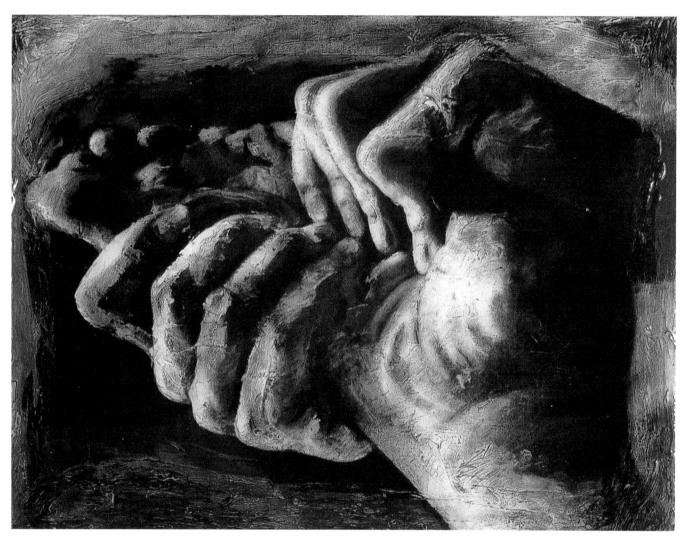

BIOGRAPHY

Lader is Director and Founder of Chicago Printmakers Collaborative, and is on the Board of Directors At-Large for Mid America Print Council. She received her Bachelor of Fine Arts in Printmaking from Cornell University and her Master of Fine Arts in Printmaking from Cranbrook Academy of Art. Her work was exhibited widely in this country as well as overseas. In the last two years, she has exhibited her work at InsideArt, Mars Gallery and Wood Street Gallery, all located in Chicago, and at the Suburban Fine Arts Center in Highland Park. Her work has also been exhibited at Cotman Gallery in Wimbledon, England; Shinsegae Gallery in Seoul, Korea; and at the Twenty Fifth FISAE Ex Libris Congress Artist Bookplates Exhibition in Milan, Italy.

87. *Reflect*
1996
Charcoal on Paper and Plaster
Covered with Plastic Polymer
20" x 26"

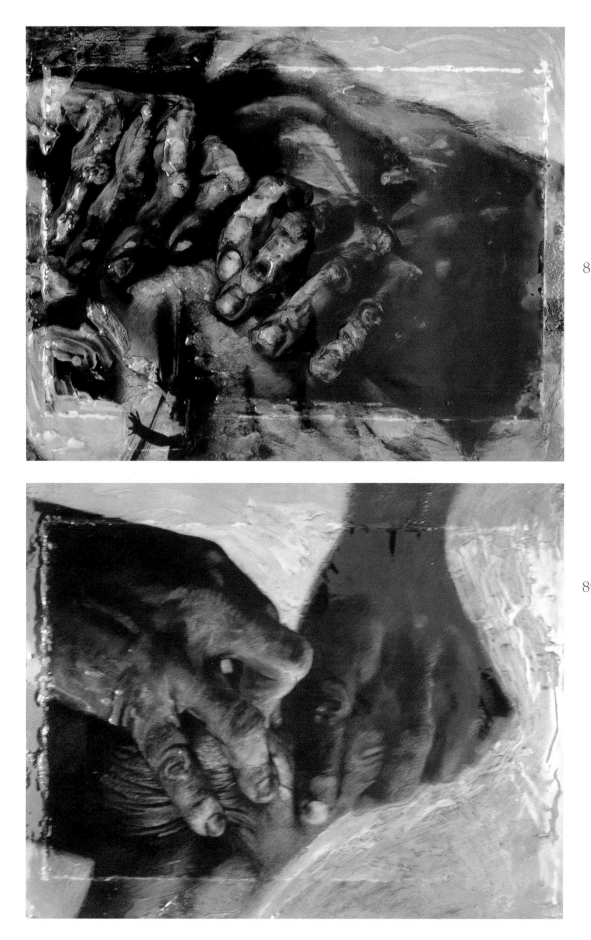

88. *Hold*
1997
Charcoal on Paper and Plaster
Covered with Plastic Polymer
20" x 26"

89. *Press*
1997
Charcoal on Paper and Plaster
Covered with Plastic Polymer
20" x 26"

Min-Ja Oh Lah

"What is seen was not made out of things which are visible. That is what I want to convey to you. My intaglio process prints, woodcuts, silkscreen and oils are made from a multitude of sizes, forms, lines and points. You cannot see the process, but the painting breathes on its own, filling the space on canvas and in the viewer's mind... much as a child grows and develops depth as he grows. I contrast open space with crowded structures, flatness with depth, and brightness with darkness. Through my art, I hope to tell you that life is terrifically both simple and complex, and we may not understand what we see in life, but we can still step back, look and appreciate."

BIOGRAPHY

Lah is a native of Korea and spent most of her life in the city of Seoul. She began her pursuit of art at Ewha Women's University in Seoul, concentrating in oils. She exhibited her work at the National Art Competition in Seoul.

After graduation, Lah travelled extensively throughout Europe, touring its museums. She then studied at University of Wisconsin-Madison, earning her Master's degree in Art. She returned to Korea for a period of time where she exhibited her work and taught Oil Painting at Sohrabul University. She has now returned to the United States and finally settled in Chicago's northwest suburbs. Lah exhibits her work widely in the metropolitan area.

90. *With Sunsets*
1997
Printing on Zinc Plate
23½" x 17½"

91. (above)
 With Ancient World
 1997
 Printing on Zinc Plate
 12" x 18"

92. (right)
 Untitled No. 8
 1996
 Woodblock
 12" x 9"

Itala Langmar

"All my awards before 1995 were given for my paintings, prints and drawings. In May, 1995, I wrote my first poem which won third prize from The National Library of Poetry. After that, many more poems followed and I started incorporating them into my paintings. I realize now that I was writing poems to elucidate my sometimes mysterious little paintings and to clarify what or whom inspired them.

I am now working on themes of nature and spiritual concerns. Short poems on leaves are organically etched in abstract, sculptural paper inspired by them. Longer poems about knowledge are inscribed in irregular squares that refer to a veil, and the underlying geometry of the composition is classical. My methodology is to immerse the poem in its lyrical container and explore it many times in different colors and shapes.

Because the concepts of knowledge, serenity, beauty and forgiveness are not easily describable, great effort is put into leaving space for the viewer to interpret the piece and complete the poems with his or her own sensibility."

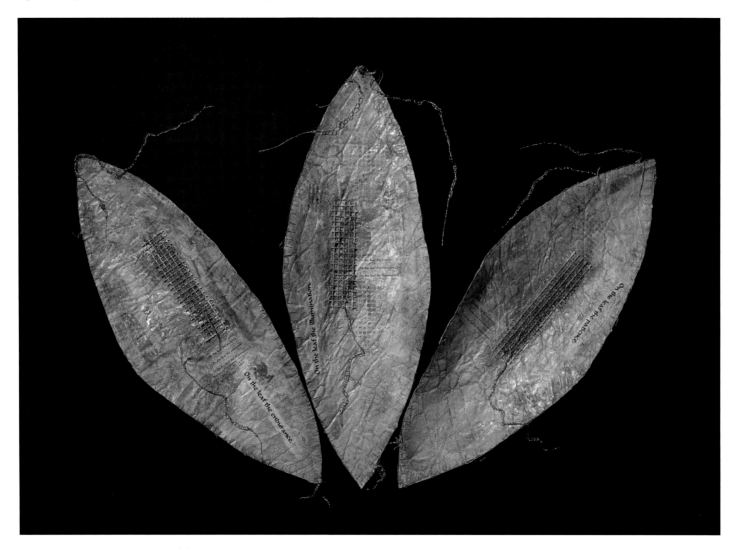

93. *Meditation on Patience, Meditation on Endurance, Meditation on Illumination*
1997
Acrylic, Fiber and Torn Pages of Poetry on Hand-Made Paper
Triptych, 23" x 8" Each

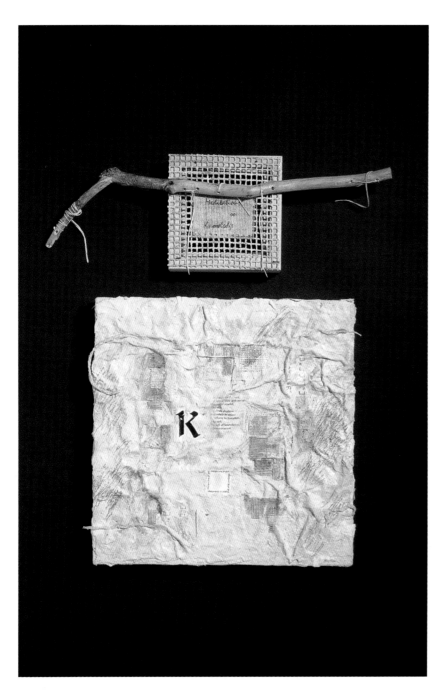

94. *Meditation on Knowledge 1*
1998
Acrylic, Fiber and Torn Pages of Poetry
on Hand-Made Paper
12" x 12" and 5" x 5"

The poem reads as follows:

THE VEIL OF KNOWLEDGE

To search for the veil,
the veil of blue and purple,
the veil of scarlet.
The veil:
a golden shadow of ecstatic enjoyment,
unlimited in space,
indefinite in duration.
The veil:
the veil of knowledge,
a pomegranate
upon the hem of one's robe.

BIOGRAPHY

Langmar received her Doctorate degree in Architecture from Venice University in Italy. She has studied art with many private instructors since the age of six and at various Illinois art education centers such as The School of the Art Institute of Chicago, Evanston Art Center, North Shore Art League in Winnetka and Suburban Fine Arts Center in Highland Park. She has received many awards for her paintings, prints and drawings. Her most recent award for her painting was a work on beauty, entitled *Bellezza* which was inspired by the Italian painter, Botticelli.

Langmar has collaborated with another artist, Dale Miller (see page 82) on some pieces.

David McElroy

"When I was in the 4th grade, my mother, a children's librarian, was told by my teacher that I was not comprehending what I was reading. Needless to say, this was distressing. One afternoon, I was reading an assignment pertaining to the Golden Gate Bridge. The paragraph in effect read as follows: Under a blue sky and golden sun, with birds flying overhead lies the Golden Gate Bridge, spanning so long, standing so tall and built in such and such a year. My mother asked me what the important points in that paragraph were, and my reply was, "Blue sky, golden sun and birds overhead." In exasperation, she thought her son is never going to get it.

95. *A Wisp*
1997
Pastel
23" x 30"

I would say I got what I needed. My heart and eyes still look to the skies. I find the colors and compositions reflect the range of moods and emotions of us earthbound mortals. My work, while generally representational is also fused with elements both abstract and surreal. As children, we searched for the fuzzy ducks and dancing dinosaurs. As adults, we dream of soaring above to escape the workaday world, to rise above the mundane and the turmoil that surrounds us. I seek to draw people into the clouds. There is a spirituality to be found in them. Their beauty, majesty and what they portend are a constant source of inspiration and wonderment. Even when the clouds are dark or foreboding, I still keep an area with a source of light or hope. As an artist, my challenge is to convey this to my audience and lift them and their spirits.

97. (opposite, bottom)
Sky Rider
1993
Pastel
30" x 39"

96. (above)
Wowastelaka 'Sacred Love', 1997, Pastel, 23" x 30"

My interest in Native Americans goes back 30 years when I read *The Soul of the Indian* by Oniye Sea. They were the silent minority of the Civil Rights Movement. I was tired of the stereotypical stoic Indian of the Edward Curtis photographs, the romanticized depiction of 19th century warfare, and the demeaning mascot caricatures. There tends to be a European bias in White America against Indians as a 'legitimate' subject matter. I strive to show them as human beings with universally felt emotions.

Finally, in my approach to art, I am concerned with four key elements: the concept, the drawing, the composition and the values. If any one is weak, the piece is weak. The color is just the icing on the cake. Enjoy!"

BIOGRAPHY

McElroy is President of the Midwest Pastel Society and a Board Member of the North Shore Art League in Winnetka. He has taught classes at the North Shore Art League, Columbia College, the American Indian Center in Chicago and St. Francis Indian School in St. Francis, South Dakota. In 1996-1997, his work was exhibited at numerous national juried shows such as that sponsored by the Pastel Society of America (Yarka Award), the Pastel Society of the West Coast (Windsor & Newton Award) and the Degas Pastel Society. Local juried shows included that sponsored by the Woman's Club of Evanston, the Wilmette Public Library and the Annual Old Orchard Art Festival.

Monika Medvey

"Growing up in Cracow, Poland and Vienna, Austria, I was surrounded by visually rich, yet thematically very different and culturally distinct artistic worlds. I started painting early on, but despite my exposure to a wide range of representation methods in painting, I was never fully satisfied with the exclusiveness of an academic artistic training. Intrigued by modes of

visual representation for a wider popular audience, I turned to studying political cartoons, promotional posters, editorial and book illustrations which have greatly influenced my work since. Before moving to Chicago, I travelled extensively to Southern and Eastern parts of Europe, developing a portfolio of sketches and notebooks.

In my drawn collages, I am mainly interested in uncovering patterns of human behavior in their similarities across cultural borders, rather than in their differences. I have discovered that in order to visually illustrate these similarities which indirectly manifest themselves in dream states, I have to strike my viewers at points where thought and perception, reason and emotion, occur simultaneously. In my drawn collages, notions of culturally distinct symbols and lifestyles meet with personal memories, fears and observations. Collages that are drawn rather than physically assembled from found material enhance an uninterrupted and personalized reading of the content. The viewer is encouraged to actively participate in each scenario by questioning the ways in which meaning is attached to colors, figures, spaces and words, and in which individual emotional responses guide the recontextualization process."

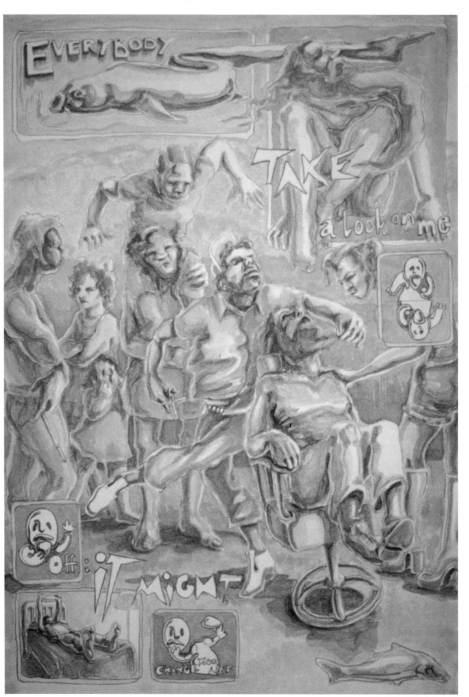

98. *Take A Look...*
1997
Watercolor and Pencil
30" x 22"

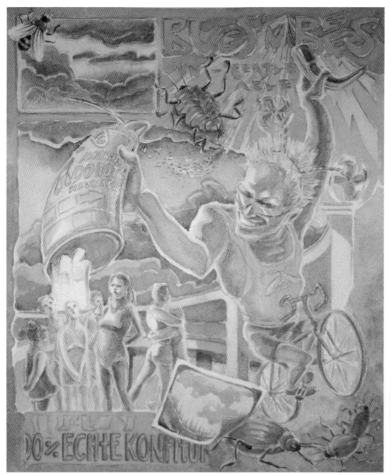

99. (left)
Bugs 'n Bees
1997
Watercolor and Pencil
23" x 18½"

100. (below)
Now News
1997
Watercolor and Pencil
24" x 22"

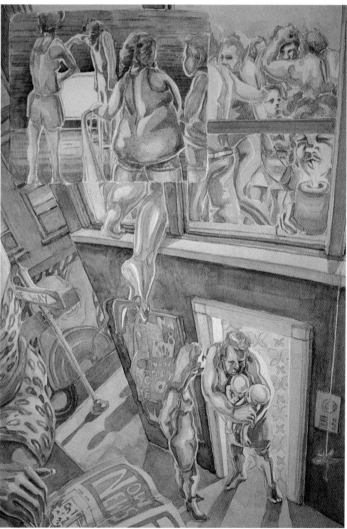

BIOGRAPHY

Medvey received her Bachelor of Fine Arts degree from the University of Illinois at Chicago in 1997. She majored in photography, film and electronic media. Currently, she lives in the Pilsen neighborhood and works as an illustrator and muralist in the Chicago area.

James McNeill Mesplé

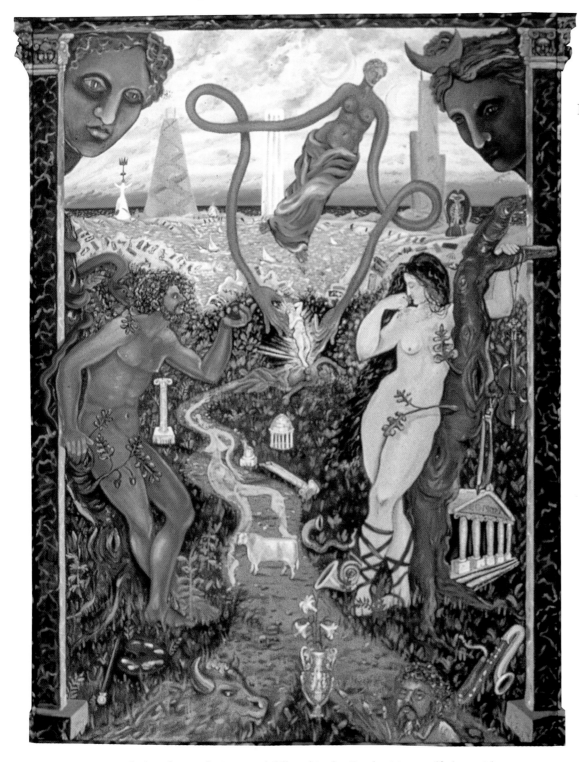

101. *Creation*
1988-1998
Egg Tempera and Oil on Canvas
48" x 36"

Creation was completed in 1988 but many areas of the painting were reworked and refined in 1998. This is not unusual in Mesplé's work. Some of his paintings have as many as three or four dates over a decade as he reworks them.

BIOGRAPHY

Mesplé attended University of Missouri and The School of the Art Institute of Chicago. He had taught painting, drawing and ceramics at The School of the Art Institute for ten years from 1978 to 1988, and held workshops in egg tempera painting for Ed Paschke's MFA students at Northwestern University from 1991 to 1993.

Mesplé designed the sets for the Chicago City Ballet Fall, 1987 premier of 'Chicago'. In 1997 he was commissioned by the Oriental Institute to create a mythological 16-foot steel beam to be embedded in the museum as a site-specific time capsule.

"My interest in mythology began during my childhood in the Ozarks. My grandfather, with whom I spent my summers, was one-half Osage Native American. He would tell tales he had learned from his mother about the wind, the rain, and the lightning and thunder. And he always had stories about the birds and animals around his farm. When I was told in the sixth grade about the Greek gods and goddesses ruling the oceans and hurling thunderbolts, I instantly felt right at home with this new-found pantheon."

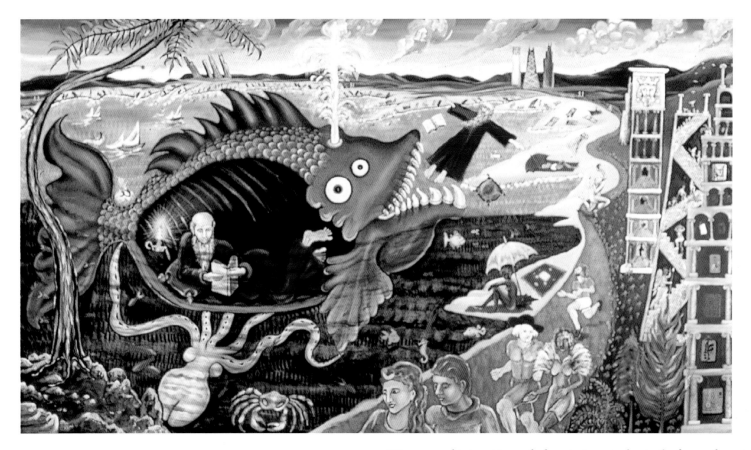

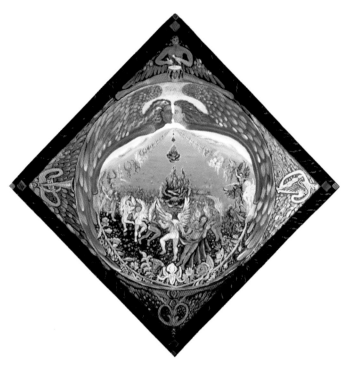

"My personal interest in mythology is, in part, due to the focus of most myths upon the never-ending battle of good and evil—the balance of the Cosmos. These myths and narratives provide a bottomless well of inspiration from which I draw my subject matter. I am interested in the symbols within the stories and the language chosen to describe events. This has led me to read numerous versions and translations of the same myth resulting in the creation of different paintings of the same subject. Myths are certainly a part of the foundation of contemporary American culture. They are stories full of wonder and mystery—two ingredients which often appear to be missing in modern life.

I feel that these myths speak to us, through the millennia, about the human condition: our weaknesses and strengths, both of body and spirit. I am not an antiquarian or escapist. I am a contemporary artist who wants to pull into the present the understanding that each stream is sacred and that each man and woman granted life is responsible for maintaining and balancing that life in relation to one's personal Cosmos."

102. (above)
 Jonah Inside Out
 1996
 Egg Tempera and Oil on Canvas
 42" x 72"

103. (left)
 Millennium Heaven
 1991
 Egg Tempera and Oil on Panel
 48" x 48"

Dale Miller

"Through my recent work, I have been exploring the idea of spirituality and the connection with the power and energy that words seem to possess. I am trying to link the very ethereal, mystical and intangible world of spirituality and the seemingly more concrete world of written text.

My personal research has led me to the Hebrew alphabet which I am utilizing in conjunction with Jewish writings in both Hebrew and English. I am intrigued by the philosophy of the Kabbalists (the practitioners of mystical Judaism) who believed that the letters of the Hebrew alphabet embody the power of God. With my paintings, I am trying to search for a hidden knowledge."

104. *Ultimately We Recognize What Has Been Revealed*
1997
Acrylic and Paper on Wood
12" x 12"

BIOGRAPHY

Miller was born in Chicago and studied painting, photography and filmmaking at University of Wisconsin and University of Illinois.

After receiving her Bachelor of Fine Arts degree, Miller worked as a freelance assistant photographer, stylist and associate producer before becoming a full-time artist. She is a member of Woman Made Gallery. Her work is exhibited in various juried shows and galleries in the Chicago area.

105. (above)
Ultimately We Recognize What Has Been Revealed
Detail

106. (right)
Knowledge and Understanding #2
1998
Acrylic and Paper
on Wood
12" x 12"

Michele Maria Mitchell

"Human existence is a possibility, not an ideal. Unspoken words of passionate voice within me seek the medium to articulate life, seeing and its possibilities. Life reveals, of its own profundity, that seeing itself is a possibility. That I may participate in this dance is my greatest joy."

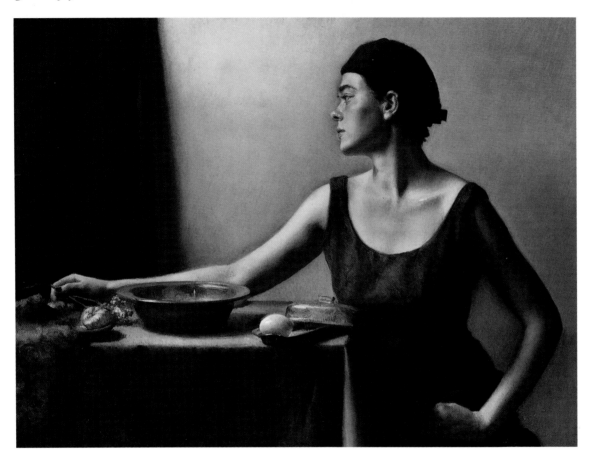

BIOGRAPHY

After attending University of Illinois in Champaign and the American Academy of Art in Chicago, Mitchell traveled extensively through Europe working with a team of planners and architects to revitalize the Greek city of Arta and studying the masters at the Uffizi, the Louvre and the Tate. Upon return, she attended the Atelier Lack Studio of Fine Art in Minneapolis, Minnesota for four years. She then studied at the Florence Academy of Art in Florence, Italy from 1994-1995.

Mitchell's work has been exhibited at the Minneapolis Institute of the Arts, Grand Central Gallery in New York, Palette and Chisel of Fine Arts in Chicago and Talisman Gallery in Bartlesville, Oklahoma. In 1997, she won the Best of Show and the People's Choice Award in the American Society of Portrait Artists International Annual Competition. In 1998, she and her husband, James Ostlund, were chosen by the Washington Society of Portrait Artists as leaders in their craft. Their work received the Best of Show and President's Award and will be hung in the U.S. Capitol. They were also a joint recipient of the Best of Show Award from the American Society of Portrait Artists and Mitchell once again received the People's Choice Award. Mitchell is represented by galleries in New York and Los Angeles. She and her husband live with their daughter, Olivia in Chicago.

107. *The Call*
1994
Oil on Canvas
35" x 47"

"Communicating with one's model is difficult but rewarding, particularly when the model has an aspiration for self-discovery. *The Call* exudes the universal longing present in each of our hearts. We (Mitchell and her model) each felt a sensitive responsibility to be honest with ourselves and to trust each other, and we both walked the journey of longing side by side."

108. (right)
Moving Toward the Light
1993
Oil on Canvas
24" x 32"

109. (left)
Sunflowers
1994
Oil on Canvas
24" x 19"

Betty Ann Mocek

THE AESTHETIC

"Urban—fascination with line—breathless, frenzied marks—capturing an explosion of glimpses—busyness—muted palette, scrubbed colors—black and white—energy of the landscape—skyline: vital? unreachable?—implied street life—senses of place—ambiguity/disorientation—whose perspective? which rhythm?

THE PROCESS

Many of my works utilize traditional printmaking methods. I usually print only with black inks. Most often I use a process called intaglio, which involves etching away various surface parts of copper plates with acids, then applying ink by hand into the depressions and transferring the ink onto dry rice paper by hand-rubbing with a wooden spoon. Sometimes I create work using silkscreen, which is a stencil and squeegee method or monotype, a one-of-a-kind painting printed from a plexiglass plate.

Most of my other work are collages. Sometimes I simply create collages without including print materials. Other times I use multiple printed images from several different printmaking methods to create a more dense and layered composition. For example, I recombine intaglio and/or relief images with my own hand-applied pencil lines, ink, watercolor sticks or other paints into what I call 'mixed media print collages'."

110. *Summer Breeze*
1997
Mixed Media Print Collage
36" x 33"

BIOGRAPHY

Mocek received her Master of Fine Arts in Printmaking from University of Minnesota. She was the Chairperson of the Chicago Artists' Coalition from 1992 to 1996, and has served on the Board of Directors since 1985. She was also a member of the Board of Directors for Paper Press, Chicago, a non-profit school, gallery and studio for papermaking and related media.

Mocek has given private instructions in relief (linoleum/wood), monoprint, intaglio and mixed media on paper since 1989. She has also taught at Gallery 37/After School Program, School of the Art Institute of Chicago, Evanston Art Center, Illinois Artisans Programs and Northeastern Illinois University. She has served as a juror for a number of art exhibitions over the years, including the Wells Street Art Fair, the New Eastside Art Works Fair, the Polish Arts Club Annual Exhibition, and the National Small Works Exhibition at An Art Place Gallery in Chicago. Among her awards are the First Place/Best of Show Award for *Zinc Dance in Brooklyn* at the 40th National Print Biennial in 1996, and the Special Purchase Award at the 'Union Images: 100 Years of Labor' Exhibit sponsored by Chicago Federation of Labor, also in 1996.

Mocek has an extensive exhibition history. Her work is currently exhibited at The Enchanted Easel and the Illinois Artisans Shop, both in Chicago.

111. (above)
On My Way Home
1980
Etching
24" x 18"

112. (right)
Zinc Dance in Brooklyn
1980
Etching
22" x 28"

Thirty to forty prints are produced from the etchings and are entered into contests even decades later. The *Zinc Dance in Brooklyn* is such an example. It won the First Place/ Best of Show Award at the 40th National Print Biennial Exhibition in 1996.

Jacqueline Moses

"Violence, ecology, and social and technological concerns have dominated my imagery for the past three years. My intent is to present pictorial essays on these aspects of life through the narrative content in each image. I use my paintings to depict our world from an altered perspective, freezing life into a perpetual comatose state, and into some illusory world between states of being. Elements of the urban and natural landscapes are rendered in a stylized, heightened realism with the objects and settings juxtaposed into surreal combinations that seem inappropriate and disturbing.

My travel through Eastern Europe and the Ukraine resulted in a series of paintings entitled *The Throes of Progress*. I was forced to re-evaluate and further appreciate the concept of democracy. This group of paintings quietly reflects the ever present threat of war and the concrete reminders present in each country that past wars have left their permanent marks and universal peace is still not a reality.

113. *Throes of Progress: Quiet Invasions*
1995
Phototransfer and Oil
48" x 62"

My most recent body of work deals with the many facets of integration: artistic, technological, physical, political, social and spiritual. These paintings are a combination of photographic transfers and oil on canvas. Concrete images of items produced and representative of man are used in combination with images of our western landscape and modern technology. The purpose of this is to visually project what our future holds, and to show the possible effects of cultural crosscurrents and the obvious need for integration on both the physical and spiritual levels.

At present, my intent is to further explore a seamless integration of photographic transfers and my oil paintings. Although not my main focus, I use the technique and the media to alter the imagery as we see it. In this manner, I hope to broaden the viewers' perspectives and their interests in each painting, encouraging their active involvement through visual and intellectual stimulation."

114. (left)
Integration: Infusion
1996
Phototransfer and Oil
24" x 18"

BIOGRAPHY

Moses holds a Bachelor of Fine Arts degree from the School of the Art Institute of Chicago and a Master of Fine Arts degree from Northern Illinois University in DeKalb. She has had many solo and group exhibitions locally and abroad. In 1997, her work was exhibited at Galleria Arte Moderna in Ferrara, Italy; and Galerija Likovnih in Gradec, Slovenia. Her work is in a number of museum collections, including Tucson Museum of Art, Indianapolis Museum of Art, Rockford Art Museum and the Illinois State Museum in Springfield. She has been in various publications such as *Art News, Art Calendar, Chicago Tribune, Reader, Pioneer Press, Kalamazoo Gazette* and *Hyphen Magazine*.

115. (above)
Passive Intrusion: Mars
1997
Phototransfer and Oil
36" x 48"

Richard A. Napier

"In my recent work, I have been exploring light as it manifests itself in the urban landscape. The structure the buildings provide and the formal problems these motifs present are quite challenging and intriguing to me. My choice of subject matter is also partly based on sentiment as well. Chicago is home to me and I feel there is much beauty in the neighborhood character.

In these compositions, I am trying to distill my subject down to its basic components and intensify what is most elemental. More specifically, my work is created in the light of the late afternoon. Seeing in terms of light and dark imposes order. To vary the mood of the picture, I use light to add drama and power, or create a more meditative atmosphere. The light can add a peculiar intimacy and sometimes the effect can border on a surreal, heightened reality. Always, however, light is at the root of what makes a certain place 'that place at that time'."

116. *Sidewalk Sale (Chicago Ave.)*
1997
Watercolor and Gouache
11" x 14"

BIOGRAPHY

Napier received his Bachelor of Fine Arts in Studio in 1993 and his Master of Fine Arts degree in 1995, both from University of Missouri. In 1994, he had summer study in Italy with the Art Research Tours and International Studios (ARTIS). After graduation, he worked as a preparator at Lisa Kurts Gallery in Memphis, Tennessee. As preparator of the private, commercial art gallery, he was responsible for hanging the monthly exhibitions of contemporary artists working in all media, unpacking and recording all incoming shipments, packing and shipping all outgoing shipments and organizing the delivery and hanging of locally sold pieces. He was also responsible for the appearance of the gallery, keeping up-to-date records of the location of the entire inventory of works of art. He now works as a preparator at Perimeter Gallery in Chicago.

Napier received the Grace and Walter Byron Smith Scholarship in three separate years to attend the School of the Art Institute of Chicago's Ox-Bow Summer Program. He won Honorable Mention in 1993 and Second Place in 1994 at the Annual Boone County Art Show in Columbia, Missouri. His work was exhibited at the Suburban Fine Arts Center in Highland Park in 1997 and 1998.

117. *Ashland between Augusta and Walton*
1997
Watercolor and Gouache
14" x 11"

118. *Los Hermanos Poolroom*
1997
Watercolor and Gouache
14" x 11"

Kathleen Putnam Newman

"As a landscape painter, I am primarily interested in responding to the color and patterns of light. Around Chicago, our lakefront harbor settings, skies and reflective patterns of water constantly inspire me. The Indiana Dune National Lakeshore, just along the bend at the bottom of Lake Michigan, is also a source of visual excitement with the changing shadows and light during different times of day and seasons.

I love working outside and work more and more on location. I am challenged by the quickly changing light and atmospheric conditions. Chicago offers so much to my senses; even the varieties of gray are becoming more interesting to me. My current work responds to the flat, watery landscapes out in the forest preserves near my home. I'm also back and forth to the city to respond to the rapidly changing environment on the near west side—of new and old, people and buildings, reflections in windows and doorways."

BIOGRAPHY
Newman studied Fine Art and Illustration at the School of the Art Institute of Chicago and the American Academy of Art in Chicago. She studied with Al Brouillette, Jeanne Dobie, Albert Handell, Gregg Kreutz, Irving Shapiro, Burt Silverman and Sally Strand.

119. *Sundown*
1997
Pastel
22" x 28"

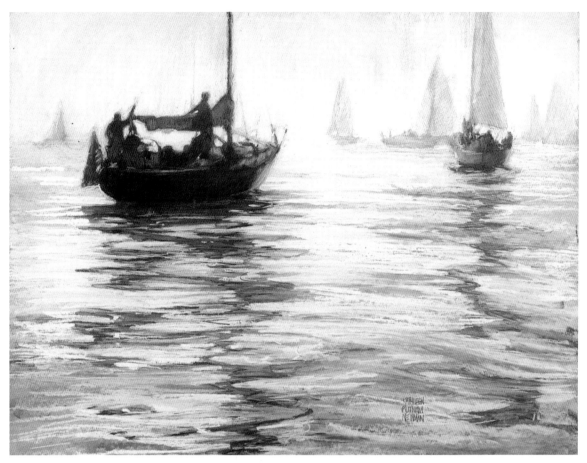

Newman's work was shown in many juried exhibitions and she has won numerous awards, including the Creativity Award and Signature Letters at the 22nd Annual Midwest Transparent Watercolor Society Show; First Place Award at Artscape Hyde Park '96 (sponsored by the Smart Museum in Chicago); Third Place and People's Choice Awards at Artscape Hyde Park '97 (sponsored by the Museum of Science & Industry); and a Merit Award at the 1998 Annual Other Side of the Lake Exhibition in New Buffalo, Michigan. She is a Signature Member of the Midwest Watercolor Society.

120. (above)
Waiting to Start
1998
Pastel
28" x 34"

121. (right)
Running the Line
1998
Pastel
28" x 34"

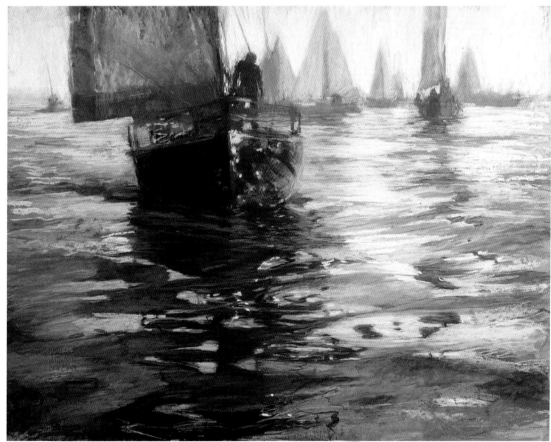

Julia DelNagro Oehmke

"Art is limitless and it compels me to work. We are creatures who need the near and the familiar as well as the exotic. Art arises in the human spirit beyond the reach of words. It comes from the levels of our deepest memories.

My recent work represents women of the world and what they have contributed to society."

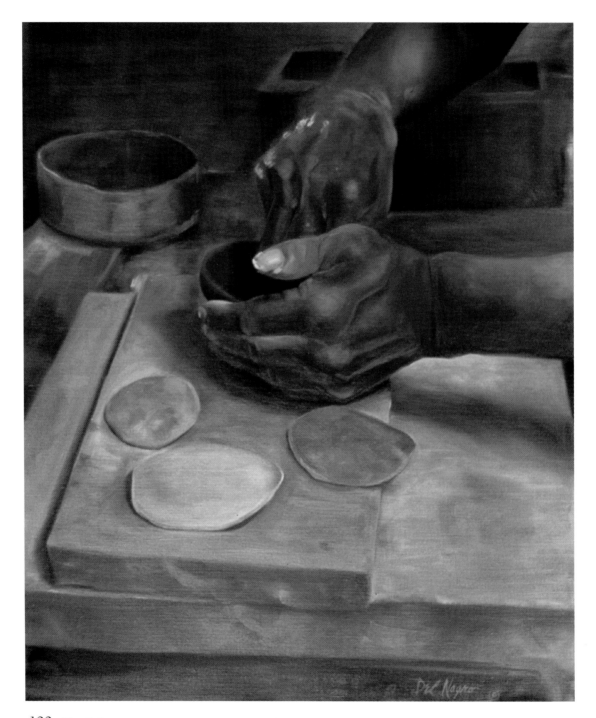

122. *Blue Rain*
1995
Oil on Linen
26" x 22"

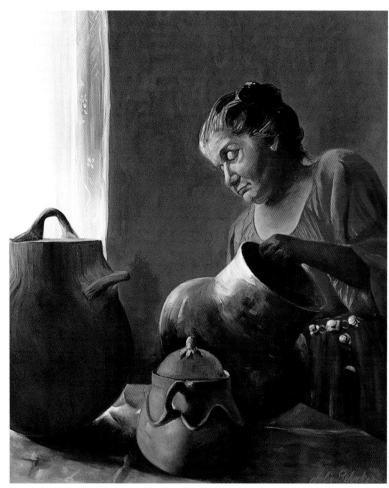

BIOGRAPHY
Oehmke studied at The Drisi Academy of Fine Arts in Glenwood, Illinois and attended Ron Riddich's Workshop at the American Academy of Art in Chicago. She is a member of the Board of Directors for The Professional Artists Alliance and a member of the Board of Directors for The Municipal Art League of Chicago. She is also the Treasurer for the Chicago Society of Artists and has been self-employed for 25 years.

Oehmke has received a number of awards over the years, including the Third Place Awards in 1988-1990 and the People's Choice Awards in 1989-1990 at the Italian Cultural Affair Exhibition, Navy Pier, and the 1996 Members Show Award at the Northern Indiana Members Show and Competition. Her work has been shown at various national and regional juried competition exhibits such as the Oil Painters of America National Exhibition held in San Antonio, Texas in 1995 and the Oil Painters of America Regional Juried Exhibition held in the same year at Nymeyer Gallery in Chicago. She is also an art agent, presently representing artist Peter Volay.

123. (above)
Mother Earth
1997
Oil on Linen
28" x 22"

124. (right)
Gabriella
1995
Oil on Linen
42" x 28"

James Michael Ostlund

"My interest lies in the arrangements encountered in our natural world. As my journey unfolds, I aspire to create paintings which are based on my personal experiences and which embody a sense of beauty and echo a common language that speaks within us all."

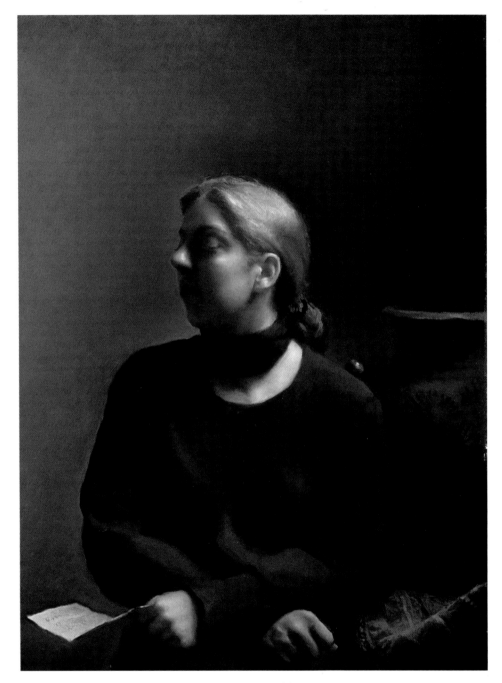

BIOGRAPHY

Ostlund was born in Minneapolis, Minnesota. His training in art began at age 14. He studied at the Hennepin Technical Center in Minneapolis for three years, then at the American Academy of Art in Chicago for another three years. In the years that followed, his work won numerous awards including Honorable Mention at the 1982 Adirondack National Exhibition of American Watercolors, Long Range Fund Award at the 1985 Midwest Watercolor Society Show, Best of Show Award in Watercolor at the 1986 Municipal Art League Exhibition in Chicago, and Honorable Mention at the 1987 Palette and Chisel Academy of Fine Art Gold Medal Show in Chicago. He taught drawing and painting at the American Academy of Art and at the Palette and Chisel Academy of Fine Art.

125. *Paula*
1996
Oil on Canvas
29" x 22"

126. (right)
John Zech
1992
Oil on Canvas
32" x 23"

127. (below, right)
Garlic
1996
Oil on Canvas
8" x 9"

In 1987, Ostlund traveled to Europe and made extensive studies of the Old Masters. Upon his return, he studied with Richard Lack at the Atelier Lack Studio of Fine Art in Minneapolis for four years. Atelier Lack is an apprentice program based on the teaching methods of the Old Masters. In 1995, he moved to Italy where he taught at the Florence Academy of Art. During his European stay, he copied at major museums and painted under the influence of the Renaissance.

In 1997, Ostlund won the Best of Show Award in the American Society of Portrait Artists International Annual Competition. In 1998, he and his wife, Michele Mitchell, were chosen by the Washington Society of Portrait Artists as leaders in their craft. Their work received the Best of Show and President's Awards and will be hung in the U.S. Capitol. They were also a joint recipient of the Best of Show Award from the American Society of Portrait Artists.

Lisa Parenteau

"I work in watercolors and woodblock, linocut and monotype printing. Some of my water-colors are done from photos. Many of them are painted on location. I paint outside when-ever possible (even from my car in cold weather).

Oil painting was a passion of mine until the birth of my son, Dylan. I'm focusing on watercolors with the goal to reach a level in my painting where the expression is more fluid and strong. At that point, I will return to oils."

128. *Tree with Tentacle*
1997
Watercolor
23" x 15"

129. (left)
Boiler
1998
Watercolor
23" x 18"

130. (below)
Bonton
1997
Woodblock Print
12" x 12"

BIOGRAPHY

Parenteau was born in Chicago and studied at the American Academy of Art. After that, she joined the Art Students League in New York. In the eleven years that followed, she had many detours. She is now doing her art full-time.

Ed Paschke

"This group of new works continues to explore my ongoing fascination with the classic issue of identity as suggested through the use of metaphor and cultural signage. The duality of gender and societal role-playing is evidenced or suggested in hundreds of clues and symbols that we process daily. The spectrum of stages that connect the polarities of male and female is where I probe and experiment. These paintings are not illustrations of sociological phenomena. They are more like psychological puzzles that confront and examine the viewers' personal identity."

131. *Musica Rouge*
1998
Oil on Linen
50" x 78"

BIOGRAPHY
Paschke was born in Chicago. He received both his Bachelor of Fine Arts and his Master of Fine Arts degrees from The School of the Art Institute of Chicago. He has taught at Northwestern University for twenty one years.

Paschke's work has been exhibited at the Art Institute, the Museum of Contemporary Art, the Renaissance Society at University of Chicago, the State of Illinois Art Gallery, Wright Museum of Art in Beloit, Wisconsin and Whitney Museum of American Art in New York. In 1989 to 1990, his solo exhibit, 'Ed Paschke Retrospective' traveled from the Art Institute to Musee National d'Art Moderne in Paris and the Dallas Art Museum. He has also shown his work in galleries in Geneva, Switzerland; Paris, France; Genova, Italy; Barcelona, Spain; Milan, Italy; and Seoul, Korea. He is represented by Maya Polsky Gallery in Chicago.

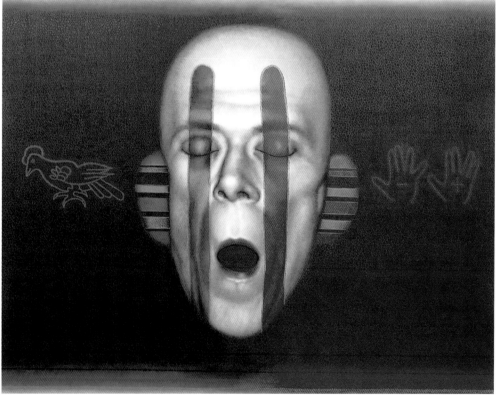

132. (above)
Organza
1998
Oil on Linen
36" x 40"

133. (left)
Interface
1993
Oil on Linen
60" x 78"

Mark Pelnar

"All of my still lifes are imaginary. Nothing is actually set up. The various objects and other subjects found within the paintings are constructed piece by piece from many different sources. The compositions are arrived at intuitively in an evolutionary way with the sketch for a painting developing over a period of several weeks, months or even years. For me, this is the most important part in the whole painting process and the most interesting. In this way, an image can grow from inside. I feel this is the best way one can achieve results that truly depict an artist's inner life.

Pictorial textures are very important to me. I feel that without a rich textural base, an image is lifeless. Texture is what gives vitality and interest. If an artist can harmoniously work in various types of textural surfaces in a single image, so much the better.

134. *Still Life with Drawings #6*
1997
Oil
34" x 28"

102

135. *Still Life with Drawings #4*
1996
Oil, 43½" x 38½"

My interest in still life is due to its potential to re-educate vision. For most people, common everyday objects are normally skipped over. A well-executed still life focuses attention on what we consider too unimportant to notice. This lavishing of attention on the overlooked aspects of everyday life can awaken one's vision to the richness and beauty to be found there, and present common objects as something fresh, as if seen for the first time."

BIOGRAPHY

Pelnar received his Bachelor of Fine Arts degree from Drake University in Des Moines, Iowa and his Master of Fine Arts degree from Tufts University and the School of the Museum of Fine Arts in Boston, Massachusetts. His work was exhibited at various national exhibitions such as the 1997 New Orleans National Fine Arts Exhibition in which he received the Juror's Award; the 10th National Fine Arts Exhibition at the Hunter Museum of American Art in Chattanooga, Tennessee; the National Drawing Exhibition at ARC Gallery in Chicago; and the 19th National Print and Drawing Exhibition at Harper College in Palatine. In 1997, he received a Runner-up Award in cover contest for the *Encyclopedia of Living Artists*.

136. *Acrylic Washed Still Life #10*
1998
Acrylic, Pastel and Watercolor
20¼" x 46"

Joanna Pinsky

"My current paintings are works on two-dimensional shaped canvases and rectangular works on paper. I work from photographs which I take of architectural structures and begin with sketches abstracting the forms in search of the basic essence of each. The subject matter consists of both urban and rural structures including decaying buildings and barns, elevated trains and highway foundations, bridges, boats and trains, and most recently, factories. The deteriorating buildings represent transitions in life both personal—the process of aging, and historic—the changing American scene. Transportation and bridges are metaphors for communication in an age in which while the world may be shrinking, family and friends often live apart, creating a sense of isolation.

137. *Causeway #*
1996
Sand, Rock Salt and Acrylic
48" x 60" x 2½"

I enjoy the challenge of developing shapes that enhance the form of the subject matter and add tension and movement to the pieces. The works on paper allow me to experiment in a more traditional format and to play with the unique quality of paper. Many of the works incorporate natural materials such as sand, gravel, sawdust and rock salt, adding both a physical dimension to the work and a visceral edge. The color is often vivid and may seem to contradict the subject matter. For me, the color is the unifying element, representing either an optimistic spirit in an unknown world or a blindness to what is actually taking place."

BIOGRAPHY

Pinsky was born in Brooklyn, New York and grew up in Silver Spring, Maryland. She has lived and worked in Cambridge, Massachusetts; Palo Alto, California; and Paris, France before moving to Illinois. She received her Bachelor of Fine Arts degree from Cornell University in Ithaca, New York. She also spent one summer studying with Jack Perlmutter at the Corcoran School of Art in Washington D.C.

Pinsky is the co-founder, Artistic Director and teacher for Art Encounter, a tax-exempt educational organization which brings visual arts understanding to people of all ages.

In 1981, she won Awards of Excellence from the Suburban Fine Arts Center in Highland Park and the Evanston Art Center and in 1983, she won the Purchase Prize at the 35th Invitational Exhibition sponsored by the Illinois State Museum. Pinsky has exhibited her work at numerous galleries in the Chicago area. Her work has also appeared on book and catalogue covers. She is represented by Perimeter Gallery in Chicago.

138. (above)
Lumber Mill
1997
Sand and Acrylic
68" x 48" x 2½"

139. (right)
Cement Plant
1997
Acrylic
48" x 66" x 2½"

All works shown are two dimensional shaped canvases on wooden stretchers that are approximately 2½" thick. Paint and materials continue around the canvases' edges.

Rita F. Price

"Creating art allows me to make a visual statement and thus begin a dialogue with the viewer.

Painting is very direct in its execution. Printmaking involves processes, and the varied technological aspects drew me to the medium. It is an additional challenge to make an inert surface come alive.

In the 1970's, I developed an intense interest in natural elements. Organic shapes and forms seemed to evolve from some inner source. Traveling abroad during the 1970's and 1980's greatly influenced my image making. The camera became an additional sketchbook and a way to gather visual information for future artwork.

More recently, I have been drawn to making monotypes. The excitement, immediacy and spontaneity of monotypes fascinated me. Between the process of painting, drawing and adding other elements to the surface, some magical transformations occur. This particular methodology allows me to paint again. In the monotype making process, transferring the painted image from the painted surface to paper causes a diffuse, more poetic effect. It can become magical."

140. *Aura of Longevity Hill*
1986
Monotype
24" x 18"
International Mineral & Chemical Corporation, Northbrook, Illinois Collection

141. (above)
The Hot Spot
1992
Monoprint
30" x 22¼"

This monoprint has three etchings
set in a monotype. The monotype
was painted in an oil-based etching
ink. This piece was completed after
the Desert Storm Operation.

142. (right)
Sunsets at Kumming Lake
1998
Etching
25" x 17"

BIOGRAPHY

Price was born in Bronx, New York. She received her Bachelor of
Fine Arts degree from The School of the Art Institute of Chicago and
her Master of Fine Arts degree from University of Illinois in Chicago.

Price is Director of Alumni Affairs, a member of the Board of
Directors and a faculty member at The School of the Art Institute of
Chicago. She is also President, a member of the Board of Directors
and a faculty member of the North Shore Art League in Winnetka.

Price's work has been exhibited annually at the National Associ-
ation of Women Artists (NAWA) Annual Exhibit in New York City
from 1985 to 1995, the National Travel Print Exhibit from 1987/1988
to 1992/1993, and the Illinois Regional Print Exhibit in Chicago
from 1985 to 1994. She has won Awards of Excellence from the
Municipal Art League of Chicago, American Jewish Arts Club,
Spertus Museum, Old Orchard Art Festival and the North Shore
Art League. She was included in the 1981-1982 edition of *Ameri-
can Artists of Renown*.

Tracy Lynn Pristas

"My creativity requires my active enthusiasm and passionate commitment to making images. Here are a few tools that I use to nurture my creativity and artistic inspiration: I take myself out dancing (it helps me solve compositional problems); I walk to the beach or cemetery with watercolors in tow; I write about my work; I talk to another artist; I explore galleries; and I take classes. As a certified yoga instructor, I utilize my knowledge of yoga and chakras (energy centers) to aid myself when I feel blocked. I feel that an artistic community is essential to my survival, therefore my studio is in a co-op and I belong to an artist support group.

My primary medium is oil painting. My technique is a direct search for the image within the paint. It's an intuitive process. For the past year, I have concentrated on a low intensity palette consisting of Indian Red, Yellow Ochre and Prussian Blue. I have a strong fascination with boats because they can be seen as a metaphor for a spiritual journey—the whole idea of passage and distance. I believe that making images requires a balance between the mind and the soul."

143. *Disturb Not Her Dream*
1996
Pastel
20" x 30"

144. (right)
**Shaped by Water and
Tidal Forces**
1997
Oil
24" x 30"

145. (below)
Soul Spiral Passage
1995
Oil
46" x 36"

BIOGRAPHY

Pristas worked as Teacher's Assistant for the printmaking studio at Evanston Art Center from 1989 to 1991. She had developed and implemented programs for the chronic mentally ill adults. She is currently a certified Hatha yoga instructor.

Pristas' woodcuts and etchings have been exhibited at Wood Street Gallery, Women Made Gallery, NEO and Esoteria here in Chicago. In 1990, she won First Prize in NEO's Dark Art Contest and in 1996, she was an award recipient of a City of Chicago Community Arts Assistance Program Grant.

Tom Robinson

"I have this obsession to create. For as long as I can remember, I've been an object maker, stretching the viewer to their furthest edge of comprehension, juxtaposing the familiar with the unexpected."

146. *Andrea*
1997
Oil
26" x 29"

BIOGRAPHY

Born in Cadiz, Ohio, a small town of 2,500, Robinson began making wooden toys at the age of four. This early interest was later cultivated at Ohio State University in Columbus where he studied experimental and multi-disciplinary art. Grounded in a tradition that embraces the fine arts, he has worked as a multi-disciplinary artist creating paintings, drawings, sculptural objects and furniture pieces from his studio in Chicago for over 20 years.

Robinson is Executive Board Director of the Chicago Furniture Designers' Association and Events Chairperson of the Chicago Artists' Coalition. His work has been exhibited at Art Junction International in Nice, France; International Art Exposition and International New Art Forms Exposition at Navy Pier, Chicago; and the Rental and Sales Gallery of the Art Institute of Chicago.

Robinson has been the curator of numerous exhibits, including the 'Local Heros' exhibit at Wood Street Gallery in 1994 and the 'Small Wonders' exhibit at Ann Nathan Gallery in 1996. He created the SOFA—Miniature Chair Competition and served as its curator from 1994 to 1996.

147. (right)
 Robin
 1997
 Oil
 30" x 30"

148. (below)
 Jim
 1997
 Oil
 29" x 31"

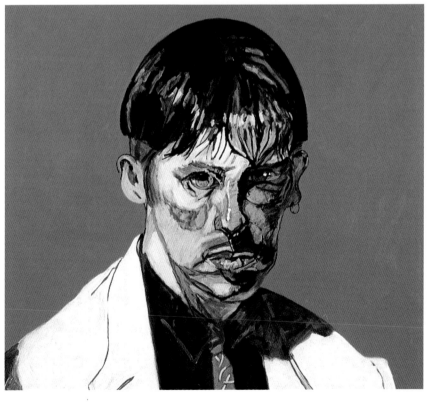

John Rush

"My interests since childhood have always been in history and mythology. I am, above all, preoccupied with the human figure and determined to bring my figure painting up to the level of mastery that existed 150 or 200 years ago."

149. (left)
Allegory
1997
Oil on Canvas
30" x 40"

150. (below)
Battle of Lexington and Concord
1996
Oil on Canvas, 30" x 80"
Commissioned by the United States National Park Service

151. *Study of a Winged Figure*
1995
Oil on Canvas
24" x 16"

BIOGRAPHY

Rush was born in Indianapolis. He graduated from University of Cincinnati with a Bachelor's degree in Industrial Design and from Art Center College with a degree in Illustration. He has worked as a freelance illustrator since 1976. In 1989, he received a commission from the government of France for a painting to be exhibited at their bicentennial celebration. His work has been exhibited throughout the United States and in Europe and Asia, and is represented in many corporate and private collections.

Rush's illustrations have received awards from the Society of Illustrators, the Society of Publication Designers and the Chicago Artists Guild. His work has appeared in many major graphic arts publications, including the *Society of Illustrators Annuals*, the *American Illustration Annual*, and *Communication Arts*, *Print* and *Graphis* magazines.

Rush lives in Chicago with his wife, Danea and divides his work time between painting, illustration and printmaking. He sells his paintings through the Eleanor Ettinger Gallery in New York.

Jeanine Coupe Ryding

"For me, the process of making a print is more of an exploration in line, color and form than a narrative. I prefer to discover forms and learn about color as the work proceeds. In order to remain focused, I rely on my drawings and sketches as I develop the prints. The meaning is in the doing or the making of the print and the discoveries that I make in the work process.

Head No. 1 was completed in 1987. In its simplified form, the head allows me to experiment by adding shapes to suggest features, either in sharp contrast or partly hidden beneath layers of color. I have learned a great deal from creating prints of heads—some 37 of them since No. 1.

Recently, I have gone back to the figure...particularly a gesture or motion frozen in time. Sketching from photographs of sculpture or of people caught in motion by the camera, I set the figure in the print by itself. As in the prints of heads, I suggest a feeling or activity by using color."

152. *Roman Head*
1997
Woodcut Print
40" x 30"

153. (right)
Diver
1998
Woodcut Print
40" x 30"

154. (below)
Washing
1998
Woodcut Print
40" x 30"

BIOGRAPHY

Ryding received her Bachelor of Arts in Printmaking from University of Iowa, Iowa City and her Meisterschuler (MFA) in Sculpture and Printmaking from Hochschüle fur bildende Kunste, Berlin, Germany. She has been Adjunct Assistant Professor of Printmaking at The School of the Art Institute of Chicago since 1989. Her work was exhibited in regional and national print exhibitions, as well as overseas. She was the recipient of numerous grants and awards, including an Award of Excellence at the 1988 North Shore Print Exhibition in Evanston; a Purchase Award at the Fourteenth Harper College National Print Exhibition in Illinois; Best of Show and Purchase Awards at the 1991 Anderson Winter Exhibition in Indiana; and Awards of Excellence at the 1992 and 1994 Hyde Park Art Center Members Show.

Ryding is represented by Perimeter Gallery in Chicago; Natalie Best of Best Portfolio in New Jersey; and Olson Larsen Galleries in Des Moines, Iowa.

Fern Samuels

"My recent work is based on a strong interest in rituals and systems (whether music, dance, theatre, poetry or nature), and variations within those systems. Identical shapes are altered with a color change or a new placement of the forms. Multiple views set up a chain reaction. Each piece interacts and has a dialogue with the other. This would not be possible to obtain within a single work. If the sequence of each piece is changed, different psychological possibilities are set up. The grid allows me to order my own inner chaos and the chaos of society."

155. *Blues Toccata #8*
 1998
 Mixed Media, Collage
 40" x 40" Overall,
 18" x 18" Each

BIOGRAPHY

Samuels received her Bachelor of Fine Arts from Mundelein College in Chicago and her Master of Fine Arts from The School of the Art Institute of Chicago. She has been a faculty member of the Art Department at Columbia College since 1976. She has also taught workshops, lectures, critiques and demonstrations at various art leagues, colleges and public institutions such as The Field Museum of Chicago, Mundelein College, Lake Forest College, Lincoln Park Cultural Center and The Latin School.

My earlier work is derived from a strong interest in archaic structures and fossils, and the literature written about them in fairy tales, myths and medieval folk stories. Surface is important to me. Using magazine photos as a base I build up images by using acrylics and hot glue on pastel cloth. I hope to convey a highly expressive, mysterious and evocative surface. I consider myself a problem solver and that these works are always in the process of becoming. I want to feel that I am continually developing my work by making discoveries and experimenting. Each new piece has new constructional and emotional possibilities for me and is explored and solved in a different way."

Samuels has had many solo and group exhibitions at various galleries and colleges. She has also exhibited her work at numerous museums, including the Museum of Science & Industry in Chicago, the Illinois State Museum in Springfield and the Smithsonian Institute, Air and Space Museum in Washington D.C. In 1998, she won a Purchase Award from McNeese University in Louisiana, and was included in the 62nd Annual Midyear Exhibition at The Butler Institute of American Art in Youngstown, Ohio. Samuels is represented by Fassbender Gallery in Chicago.

156. (above, left)
Cantata
1993
Acrylic on Paper,
Collage
27" x 39"

157. (left)
Untitled
1993
Acrylic on Paper,
Collage
27" x 39"

Vera Scekic

"My work stems from my fascination with science. More specifically, this fascination lies with biological and astronomical phenomena that depend on technology, such as microscopes, telescopes and scanning devices, for resolution. In addition to their aesthetic appeal, these mediated images ask us to rethink our conceptions of self, scale and context.

I invite the viewer into my work by emphasizing its material aspects. Through repeated applications of graphite, charcoal and pastel on textured and stained paper, the surface is transformed. Because paper accepts only a limited number of passes before it is fully loaded, the viewer can envision the entire process that culminated in the work on the wall. That aspect of drawing—its relative openness to scrutiny and reconstruction—parallels my interest in exploring our desire to 'see' beyond sensory limits and determine how things fit and function together, from the most minute to the largest system.

By using only basic drawing tools, I try to link my work to a mark-making tradition initiated thousands of years ago when humans first put a burned stick to the stone. I invite the viewer to ask whether, in a technologically dependent society, work produced with such simple tools can offer complimentary and sufficiently complex avenues for understanding ourselves and our surroundings. My goal is to weave the language of art and science into a visually poetic syntax that humanizes the iconography of science and reaffirms the relevance of art created by hand."

BIOGRAPHY

After receiving a Bachelor's degree in History from Stanford University, Scekic studied Studio Art and Art History at City College of San Francisco. Her work has been shown at various juried exhibitions such as the Northern National Art Competition at Nicolet College in Rhinelander, Wisconsin and the 39th Annual Beloit and Vicinity Exhibition at Wright Museum of Art in Beloit, Wisconsin. Locally, her work has been exhibited at the Fine Arts Building Gallery and the Wood Street Gallery. Her work was also shown in a solo exhibition at Artemisia Gallery in 1998.

158. *Chromosomes & Sea*
1997
Pastel, Charcoal and Graphite on Paper
16½" x 6¼"

159. (above)
**Chromosomes &
Particle Tracks**
1997
Pastel, Charcoal and
Graphite on Paper
7" x 8¼"

160. (right)
Particle Tracks
1997
Graphite on Paper
5" x 5"

Amy Lee Segami

"For centuries, fine arts such as classical music, novel and paintings have been open to interpretations. However, in this day and age of high tech and overflow of information, so much is presented to us in a neat and slick package. Our country is yearning for creativity and innovation which can only come from imagination.

As a contemporary artist, I would like to invite the viewers to be active participants: Spend a few moments with the art. Ask yourself what you see and how you feel about the images. Stretch your imagination and share your interpretations. There are no right or wrong answers as in solving the problems in life. Here, it is the human experience and passion that count.

Water is very important to our lives, so is the art of imagination, and so is Painting on Water™ which stimulates our imagination."

"Painting on Water™ involves applying acrylic paint with a pointed Chinese brush to the surface of water. The image is then lifted off with a sheet of rice paper."

161. *Mirage*
1997
Acrylic on Paper
16" x 20"

162. *Dreams of Water*
1997
Acrylic on Paper
32" x 40"

BIOGRAPHY

Segami received her Bachelor of Science and Master of Science degrees in Mechanical Engineering from the Illinois Institute of Technology. In the 1980's, she left her corporate career as a fluid mechanic engineer to study traditional Asian art forms, such as Ikebana (flower arrangement), Cha-no-yu (tea ceremony), Sumi-e (ink painting) and Taichi (martial art and calisthenics). Applying the principles of fluid mechanics, she revived the nearly lost Asian art of Suminagashi, a painting on water technique and transformed the traditional medium into a contemporary art form.

As a professional speaker, Segami lectures on the integration of art and science. Her works are in numerous private collections and the permanent collection of Museum of New Mexico in Sante Fe. She was interviewed on NPR and BBC. Among the honors she has received is Chicago's Outstanding Citizen Award in recognition for her extraordinary ability to bring science and art together.

Florette Sokulski

"My subjects are varied; however, I concentrate on capturing the quality of sparkling sunlight and shadow patterns, forming shape and design. A diverse palette is used to add a dimension of warmth and emotion to my work. I prefer to leave each painting with only an impression, expressing the excitement and vitality of a single moment in time."

BIOGRAPHY

Sokulski is a graduate of the fine art and illustration curriculum from the American Academy of Art. She worked as a commercial artist and illustrator, and has taught watercolor classes at Harper Community College in Chicago.

Sokulski was the featured artist in the July, 1990 publication of the *American Artist* magazine. Her work has been exhibited from Soho New York to the San Francisco Bay area, and accepted in such national and regional shows as the Louisiana Watercolor Society 19th International Exhibit; the National Museum of Women in the Arts; the 1990 New England International Exhibition; the 1990 Women Artists of the West Exhibition; Art USA International; the 1993 Marin Society of Artists Exhibition in Marin County, California; the Norris Center Watercolor Invitational in St Charles, Illinois from 1989 to 1996; and the Elk Grove Art Center Show in Illinois from 1989 to 1995. In 1994, she won the Best of Show Award at the Glenview Festival Exhibition. Her paintings hang in many private and corporate collections.

163. *Isle of Capri Harbor*
1997
Watercolor
38" x 30"

164. *Rooftops in France*
1997
Watercolor
38" x 30"

165. *YesterYear Chicago*
1996
Watercolor
40" x 30"

Gregg M. Stecker

"To me, painting is a journey to unexpected places: places of color, places of humor and places of joy."

BIOGRAPHY

Stecker was born in Detroit, Michigan. He graduated from Michigan State University with a major in Economics and a minor in Fine Arts. He first worked as a graphics designer for 10 years. Then he worked as a Senior Art Director at Leo Burnett Company, an advertising firm, for 25 years. In 1995 he left advertising to paint full time. His work encompasses the abstract and the figurative modes.

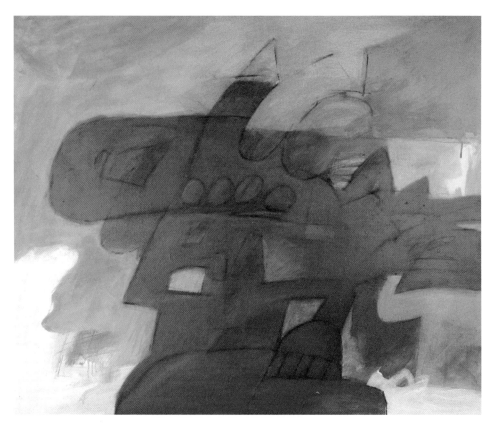

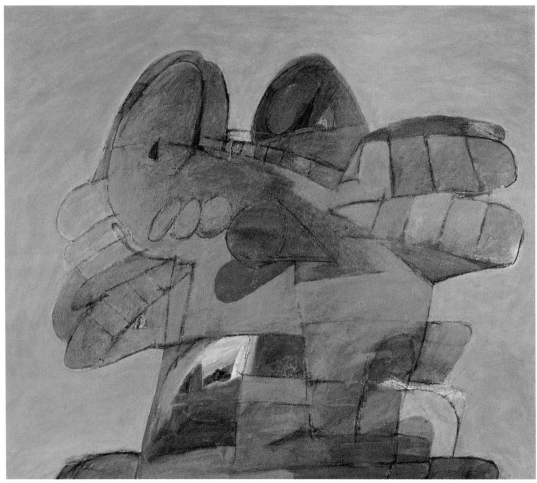

166. (above)
Untitled # 4
1996
Oil Stick and Acrylic
37" x 45"

167. (left)
Untitled # 3
1995
Oil Stick and Acrylic
36" x 42"

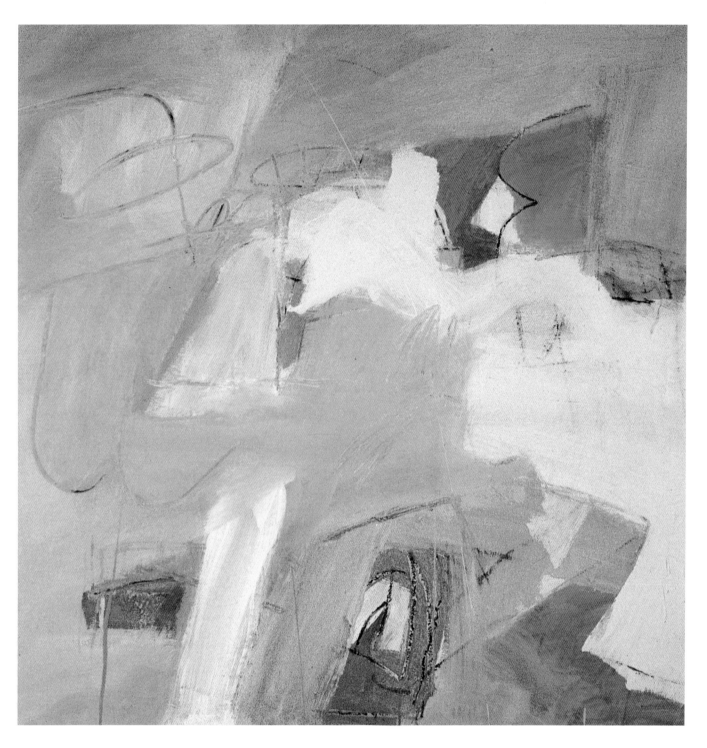

168. *Untitled # 2*
1997
Oil Stick and Acrylic
41" x 41"

Charlie B. Thorne

"My objective is to capture the moments of rough beauty in the urban environment as I see them: a darkening but still bright sky with thick shadows of twilight below; bits of calm surrounded by the din of the city; a cluttered yard made lovely by fresh snow. Everyday objects are made visually poetic through lighting and isolation.

I try not to judge or add meaning to what I draw. Rather, I express a common response to a given scene—a response we might all share if we took the time to notice."

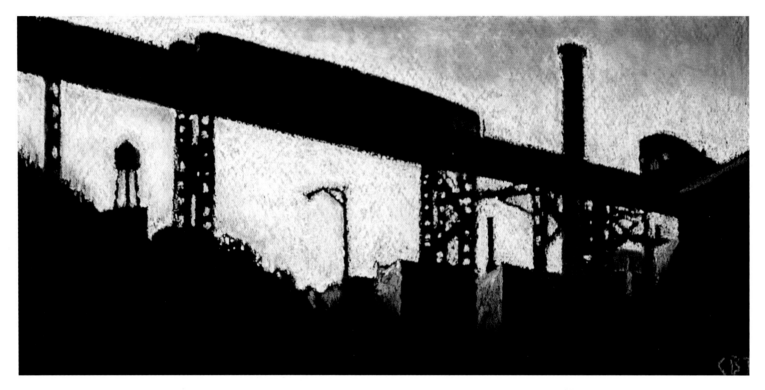

169. *Evening El*
1996
Oil Pastel on Black Board
8" x 16"

BIOGRAPHY

Thorne was born and raised in Bensenville, Illinois. He moved to Chicago while attending the American Academy of Art and has been a Northside resident ever since.

Thorne has been in exhibitions sponsored by the Wicker Park Art Gallery and the Northshore Women's Art League. His work has appeared in juried exhibitions at both Northwestern University and University of Chicago, where he won a First Place Award. In 1992, he was asked by the Greenview Arts Center to participate in The Neighborhood Show at their Rogers Park facility. This group show subsequently inaugurated the Randolph Street Gallery in the Chicago Cultural Center. In 1994, his work was presented at a group show entitled 'Urbanity' in the John Hancock Signature Room on the 95th floor.

Thorne has created illustrations for a book by the San Francisco poet Douglas Blazek. His drawings were published in the Spring 1994 issue of *Jubal*, a literary magazine published in New Orleans. Locally, he has done poster and graphic work for WXRT Radio and the Quiet Knight Nightclub, Independent Precinct Organization-Independent Voters of Illinois and many musical groups.

Thorne co-curated 'Precious Leavings', a retrospective of his mentor—the legendary Wicker Park resident and artist Eddie Balchowsky. Balchowsky's Honore Studio doors were always open to those interested in creativity. After his death, Thorne took over the Honore Studio. Since 1993, Thorne has participated annually in the Around the Coyote Art Festival of Wicker Park.

170. (left)
Shadow
1998
Oil Pastel on Black Board
12½" x 9"

171. (below)
Snow Garden
1996
Oil Pastel on Black Board
8½" x 18¼"

Lee Tracy

"Formally, my paintings and works on paper use both figurative and abstract approaches. Responding to the simplicity and complexity of everyday life, objects become shapes with just enough detail to be recognizable and are chosen for their specific meaning. Through my art, my concerns with themes of nature and interrelationships become visual.

While continuing to paint on canvas, I have been working in mixed media, collage of textured fabrics and dress patterns, often incorporating the construction of a paneled grid. Each exploration in texture and format inspires another form of image making. Even as I gather new information, I continue my interest in conveying the emotion of a recent experience."

172. *First Breath*
1997
Oil on Panel
100-4" x 4"

173. (left)
Indoor/Outdoor
1997
Oil and Turf on Canvas
51" x 46"

174. (left)
Rush
1997
Dress Pattern, Acrylic on Paper
46" x 39"

BIOGRAPHY

Tracy was born in Maine. She attended The Milwaukee Institute of Art and The Art Institute of Boston before receiving her Bachelor of Fine Arts in Painting from The School of the Art Institute of Chicago in 1989.

Tracy has participated in various group shows in New York and the Midwest. She has had solo exhibitions at Lyons Wier Gallery, Artemisia Gallery and Vedanta Gallery here in Chicago. In 1994 and 1995, she received an Illinois Arts Council Fellowship, two Illinois Arts Council Short Term Residency grants and a City of Chicago Community Arts Assistance Program Grant. Her work is in numerous private collections.

Al Tyler

"My art is a statement of eclectic form of color. My medias are pen and inks, pastels, markers, serigraphs and oils. I have many subject matters, but my main subject matter is the glorification of the African-American people. We are a race of many rich colors, from the blue-black to the lily-white. We are so vibrant, strong and beautiful that my brushes explode with the many rich eclectic skin pigments and hues. We are not flat black, brown or tan silhouettes. As an artist, I will never paint my people a flat color. My brushes will always have a flair of color for my people. As my old art teacher used to expound, 'MORE COLOR!' "

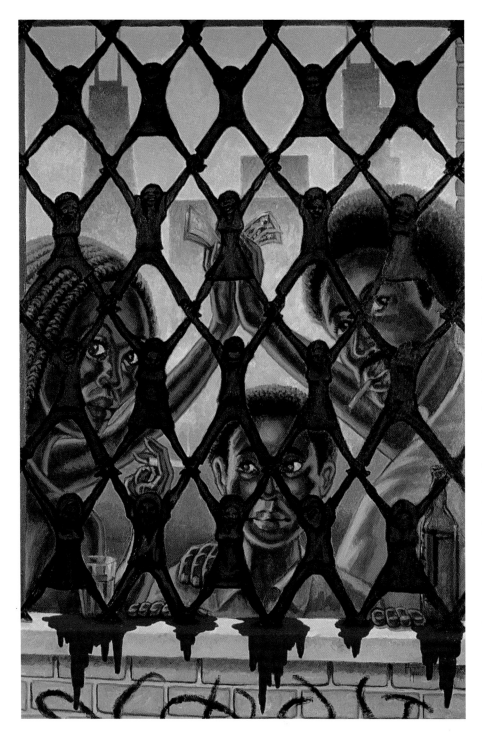

175. *Project Generation*
 1988
 Oil on Canvas
 36" x 24"

BIOGRAPHY

Tyler was raised in Chicago's Woodlawn community. He began his artistic studies on Saturdays at the age of 12 at The School of the Art Institute of Chicago. He was also influenced by his art teacher, Cornelius Johnson, at Englewood High School. In 1958, he received his Bachelor of Fine Arts degree from The School of the Art Institute.

While at The School of the Art Institute, Tyler became interested in mural painting. This led to a commission to paint a mural at Sexton Elementary School in Chicago. Then for two years, he was a staff artist for the Safety Office of the First Marine Corps Division, United States Marine Corps.

Encouraged by Margaret Burroughs, a visual artist and founder of the DuSable Museum of African-American History in Chicago, Tyler pursued his Graduate Studies in oil painting and the fresco method of mural painting at La Escuela Nacional de Artes Plasticas in Mexico City.

176. *Sister Sadie at the Jazz Fest.*
1995
Oil on Canvas
36" x 30"

177. *Two Butterflies*
1995
Oil on Canvas
40" x 30"

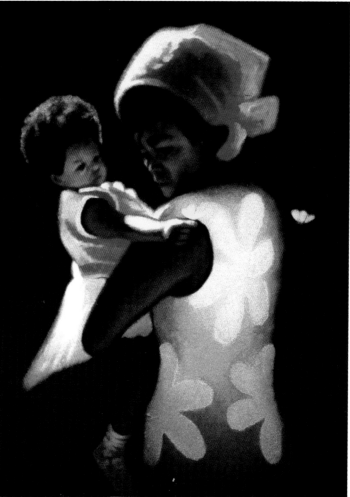

As an artist, Tyler's career has tapped into many facets of the visual arts. He has co-owned the 353 East Gallery and the Afam Studio and Gallery, acted as promoter of Gallery at Home shows with Jose Williams, and served as advisor for many art-related projects throughout the Chicago metropolitan area. His work is in many permanent collections such as The State of Illinois Collection in Springfield, DuSable Museum, University of Illinois in Champaign-Urbana and the McCormick Place Convention Complex.

Gabriel Villa

"In a painting, unlike reality, nothing is tangible. A child knows this by instinct. As we grow older, this light fades. Logic does not exist when the flesh and soul are young. Everything is emotional and intuitive and every issue in life is of great urgency when one is young. I want to always be connected to this aspect of life. Art reminds me of this on a constant basis.

All of my paintings come from deep emotion. They are not born in the mind; they gestate from personal history through my nervous system. I am never completely clear what my images represent. I have learned to trust and have faith in my intuition as a painter. The images are formed out of childhood experiences, domestic concerns, and curiosities. Hopefully, the viewer will grasp a little bit of the excitement and experience the paintings have given me. The reality of the painting and the reality of the painter are two entirely separate ideas. The only thing that is constant in my life is the impulse to be clear as a human being. I hope this is reflected in my art."

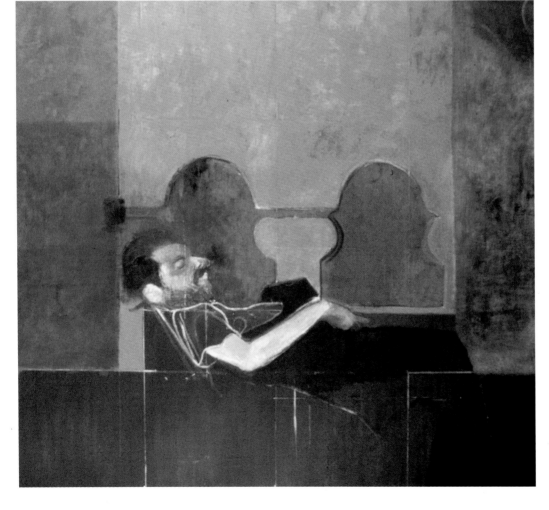

178. (above)
Still Life: Hand with Flower
1997
Oil on Canvas
13" x 13"

179. (left)
Angel En Su Recamara
1997
Oil on Canvas
66" x 72"

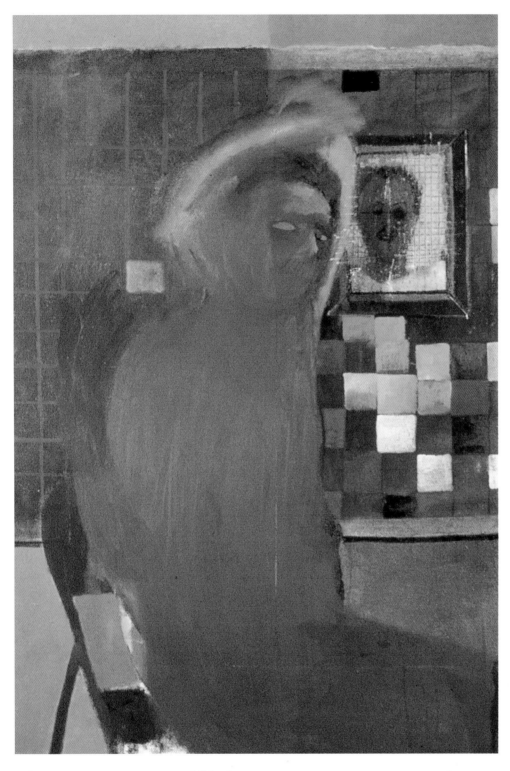

180. *Espejo/Self-Portrait*
1997
Oil on Canvas
48" x 36"

BIOGRAPHY
Villa received his Bachelor of Fine Arts in Painting from Corpus Christi State University in Texas and his Master of Fine Arts degree from University of Delaware in Newark. He also studied at The Graduate School of Figurative Art and The New York Academy of Art in New York.

Villa was the recipient of numerous fellowships and scholarship funds. He won a Purchase Award from El Paso Community College in 1988. He had worked as a gallery assistant at the Weil Gallery in Corpus Christi and the Michael Walls Gallery in New York. In 1996, he taught Continuing Education courses in drawing, painting and design at El Paso Community College.

After moving to Chicago in 1997, Villa assisted in the installation of a mural created out of mosaic tile at Stone Scholastic Academy, and also helped to paint a mural for a Pre-Fit franchise. His work has been shown at various exhibitions, including a solo exhibition at the El Paso Museum of Art and a group exhibition at Gallery 7000, Chicago Contemporary Art space.

Doris Volpe

MANY MOONS—MANY ROOMS

"This series of paintings explores the new interior spaces of thinking that are unfolding as my life progresses—new rooms and experiences are ahead for me. With many moons of living behind me, I find that life is divided into compartments or rooms for different parts of my life. Although my creative work is necessarily autobiographical, it is also universal because we all share common experiences as our lives unfold."

BIOGRAPHY

Volpe studied at Lake Forest College in Illinois and had classes with Hubert Ropp, Abbott Pattison and Ed Paschke. She has taught Studio Painting and Critique at the Deer Path Art League.

Volpe has had many one person and group exhibitions at various museums and galleries, including the former Art Rental and Sales Gallery at the Art Institute of Chicago for 15 years. She has won many awards, including the Helen Hale Memorial Award; the Martins Sudars Memorial Award and the Purchase Award at the Fall Festival in Lake Forest; an Award of Excellence at the Chicago Botanic Garden Flora Exhibit; an Award of Excellence at the Plaza Del Lago exhibit in Wilmette; a Merchant Award from an exhibit at Women's Works in Woodstock; and an Award of Excellence at the North Shore Art League Fall Festival.

Volpe's work has been exhibited at Gregoire Galleries and Rhoda Sande Gallery in New York; The Stanley Gallery in Norfolk, Virginia; and The Florida Society of Fine Arts International Exhibition held at the Florida Museum of Hispanic and Latin American Art. Her work is in many private and corporate collections.

Three paintings in the **Many Moons, Many Rooms** series are shown here:

181. (opposite, top)
Flowers of the Sun
1997
Oil on Canvas
30" x 40"

182. (opposite, bottom)
Flowers of the Moon
1997
Oil on Canvas
30" x 40"

183. (right)
Flowers of the Stars
1997
Oil on Canvas
30" x 40"

184. (left)
Another Room
1997
Oil on Canvas
12" x 16"

Aleksander Balos Walsh

"The many visual arts are languages as distinct as the spoken and written word. For me, painting is the language I find most suitable for translating what I have in mind into a palpable form that I can share with others."

185. *Last Supper*, 1 of 3
1997
Oil
Left panel of a triptych, 48" x 36" each

BIOGRAPHY
Walsh was born in Poland to a family with strong artistic tradition. He studied and traveled in Europe until 1989. He received his Bachelor of Fine Arts degree from Cardinal Stritch College in Wisconsin and made independent studies of Flemish and Italian Renaissance paintings. He also attended the Atelier Program at the School of Representational Art in Chicago. His work has been exhibited in the United States since 1991. He is also a mural painter.

186. (left)
Accepting Exclusion
1997
Oil
26" x 24"
Collection of Mrs. Washington

187. (bottom)
No Body
1996
Oil
8" x 12"
Private Collection

Duncan Webb

"Intimate moments occur in the domestic space. Within the contained space of four walls, secrets are whispered, promises are made, arrivals and reconciliations occur. The domestic space gives structure and form to intimate interaction. The corners, windows and doorways act as chambers, openings and divides that structure the emotional life. The container of the room becomes a place of emptiness and fullness, presence and absence, or intimacy and alienation. The domestic space swells with the distance between one and another.

My paintings use the domestic space to explore several themes: longing and alienation, self-absorption and interiority, returns and reconciliations, blindness and seeing (as knowing), sleeping and walking, conversations and silences. Like a writer, I develop characters (caricatures, archetypes) that play out unpredictably within the controlled plot of the domestic space. Though the characters include readers, writers, watchers and sleepers, they also include objects such as beds and drawers.

These characters move through a collection of spaces. Physical spaces such as rooms, doorways, windows and corners juxtapose with symbolic spaces such as mirrors and paintings

within paintings. This doubling of psychic space with illusionistic space determines my images. For example, the window is a divide that separates the inside from the outside; the drawer contains a secret space; the corner is a place of safety.

The images pursue the boundaries between inside and outside, close and far, and being within and being beyond. In the painted language, spaces, places, object and figure construct a narrative on nearness and distance, absence and presence, and intimacy and alienation."

188. (above)
Drawer and Three Books
1997
Charcoal and Ink on Paper
37¾" x 37¾"

189. (left)
Two Drawers
1997
Charcoal and Ink on Paper
42½" x 37¾"

190. *The Novel*
1997
Oil on Canvas
78" x 72"

BIOGRAPHY
Webb received his Bachelor of Arts degree from University of California at Berkeley and his Master of Fine Arts degree from University of Chicago. He is a full-time faculty member at the American Academy of Art in Chicago. His work has been exhibited at the Smart Museum of Art, Lineage Gallery, ARC Gallery and the Hyde Park Art Center in Chicago. In 1998, his work was shown at the Middle East International Art Exhibition and was published in a book entitled *Survey of American Drawing* in China. He is currently represented by Belloc Lowndes Fine Art, Inc. in Chicago.

Nina Weiss

"Through years of art exploration in both drawing and painting, I have come to realize that it is color and line that capture my artistic desires. To this end, I have been drawing in pastels now for over a decade.

The technique I use is one in which pastel color is not blended or smudged, but allowed to remain pure and brilliant. The chalk is worked in successive layers of color, resulting in optical mixing and visual depths. In producing these rich compositions, I feel tied to a strong history of drawing technique and landscape genre. It is the beauty of the color and the energy and expression of the drawn line that binds my work to these traditions."

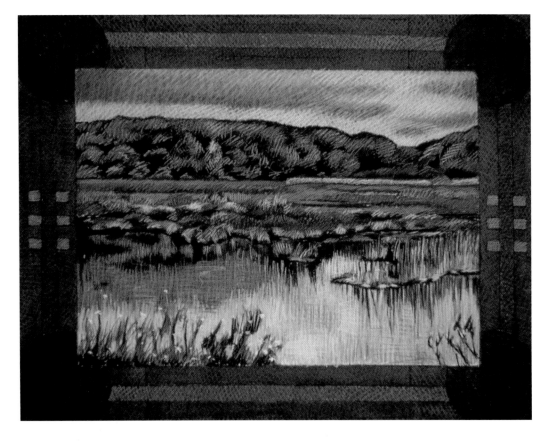

191. *Kunnebunkport Marsh*
1994
Pastel on Paper
with Hand-Drawn Frame
43" x 55"

BIOGRAPHY

Weiss received her Bachelor of Fine Arts degree from Tyler School of Art, Temple University in Philadelphia. She attended the Graduate Program in Fine Arts at University of Wisconsin and returned there a few years later for an Art Education Certification for Kindergarten through 12th grade. She teaches at The School of the Art Institute of Chicago, Division of Continuing Studies, and has covered subjects such as Color, Drawing, Pastels, Mixed Media and Illustration. She is also the Advisor for its Drawing Certification Program. In November 1997, she did pastel demonstrations and family workshops in conjunction with the Renoir exhibitor at The Art Institute of Chicago. For the past 3 years, she has been a panelist for cultural grants through the Community Arts Assistance Program sponsored by the City of Chicago, Department of Cultural Affairs. She is currently represented by Joyce Petter Gallery in Douglas, Michigan; Editions Limited in Indianapolis, Indiana; Grace Chosey Gallery in Madison, Wisconsin; and Mary Bell Gallery here in Chicago.

192. (right)
Grasmere
1996
Pastel on Paper
with Hand-Drawn Frame
47" x 45¼"

193. (below)
Summer Vision: Illinois
1995
Pastel on Paper
with Hand-Drawn Frame
39" x 57"

Donna Jill Witty

"Although I paint various subject matter, I find my work to be about an expression of light and color. Sometimes with more emphasis of one over the other, there is always a dynamic push and pull that commands an emotional response from the viewer. I don't want it to be possible for someone to stroll past one of my paintings and not notice its existence up on the wall. You can love it or you can hate it… but you must respond to it."

BIOGRAPHY

Witty attended the American Academy of Art in Chicago and studied individually with artists Nita Engle, Irving Shapiro, Tom Lynch and Jim Pollard. She has been painting professionally since 1979.

She holds signature memberships in the Midwest Watercolor Society, Pennsylvania Watercolor Society and Western Colorado Watercolor Society. She has participated in many national and regional juried exhibitions and won many awards, including a Bronze Medal at the 1996 Pennsylvania Watercolor Society International Exhibition, a First Award of Excellence at the 1997 Western Colorado Watercolor Society National Exhibition, and First Place and Business Patron Awards at the Women's Works 'Women in the Arts' Exhibit. Her watercolors are in private and corporate collections throughout the United States and Western Europe.

Witty is currently represented by The Old Courthouse Arts Center in Woodstock and The Deer Path Gallery in Lake Forest.

194. *Harbor Gems*
1997
Watercolor
30" x 22"

195. (above)
Wild Iris
1997
Watercolor
22" x 30"

196. (right)
Eden Pines
1997
Watercolor
23" x 39"

Dan Wroblewski

"Art and science have always shared a common bond throughout my life. As a major in industrial design at The School of the Art Institute of Chicago, my knowledge of art, science and technology was intensified through the understanding of the mass production assembly line. This understanding made me aware of the rhythmic quality of our environment. Rhythm and symmetry became the essence of all things for my visual orientation. These two elements are the predominant components of all things, from the smallest atomic particles to the largest objects in the universe. The exploration of rhythmic and symmetrical structures maintain a major force and an ongoing fascination of my art."

197. *Painting #47*
1994
Oil
48" x 61½"

BIOGRAPHY

Wroblewski was born in Chicago. He graduated from The School of the Art Institute of Chicago in 1968 with Bachelor of Fine Arts and Master of Fine Arts in Industrial Design and Fine Art. For five years after graduation, he worked as a full-time shop technician and shop instructor at the technical department of The School of the Art Institute. In 1975, he became an advertising artist and has worked for the same company ever since.

Wroblewski has won a number of awards for his sculptures, graphic art and paintings, including the Bell Telephone Graphic Award, and the Best of Show Award at the St. Charles Art and Music Festival, a national juried exhibition held at Norris Gallery in St. Charles, Illinois.

198. (right)
ER-28 Eternal Rhythm
1997
Acrylic on Canvas
11½" x 71⅜"

199. (far right)
ER-29 Eternal Rhythm
1997
Acrylic
16" x 83"

Takeshi Yamada

"I developed my fascination in cities' intricate culture and development when I was growing up. I grew up in Osaka, the second largest city in Japan, which was in the middle of a rapid recovery from the total destruction caused by World War II. I moved to the United States when I was 23 years old and lived in big cities such as Oakland, Baltimore, New Orleans and Chicago. The similarities and differences between cities always fascinated me. Therefore, it was natural for me to produce artwork based on what I saw, photographed, researched, interviewed and felt about the city's physical, social, material, architectural and cultural development or its people, including their origin, evolution, costumes, beliefs, folk ways, etc. in comparison to those in other cities. In this sense, I regard myself as a Visual Anthropologist.

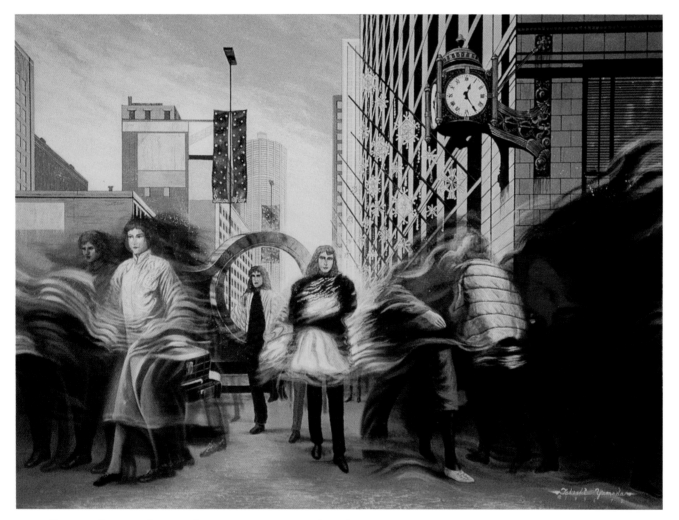

I call my style Post Photo Realism or Post Super Realism because my paintings are strongly inspired by images from uniquely animated resource photographs that I take when I conduct field works. To capture those unique resource images that are virtually imperceptible to the naked eyes, I utilize slow speed shutter, fish eye lens, multiple exposures, and color filters, etc. when I manipulate my cameras. When I return to my studio, I recapture those unique visual effects on my canvas. I spend an average of two to four weeks on each painting."

200. *Season of Joy*
1996
Oil and Acrylic on Canvas
24" x 32"

146

BIOGRAPHY

Yamada's parents were both elementary school teachers. Since the age of ten, he had studied art at various schools such as the Kiyoshi Yamamoto Fine Art Studio, Atorie Ribera School of Art, Nakanoshima College of Arts and Osaka University of Arts in Japan. After moving to U.S. as an International Exchange student, he attended California College of Arts and Crafts in Oakland. He received his Bachelor of Fine Arts degree from the Maryland Institute College of Art in Baltimore and his Master of Fine Arts degree from University of Michigan School of Art in Ann Arbor.

Yamada won his first award, a Second Prize in the Annual Juried Exhibition in Osaka, Japan at the age of 12. Many awards were to follow. In 1990, a series of 48 New Orleans Mardi Gras paintings were exhibited at the Louisiana State Museum and he was granted Key To The City and Honorary Citizenship by the Mayor of the city. He has over 20 solo exhibitions and over 115 group exhibitions in the U.S., Japan, Spain and The Netherlands since the beginning of his career.

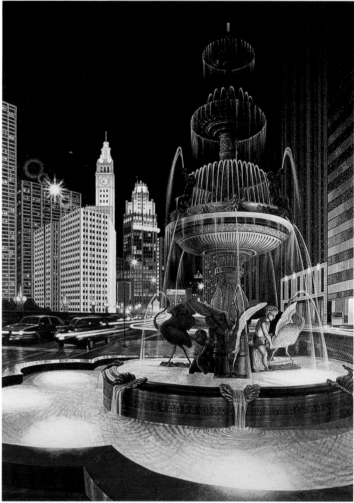

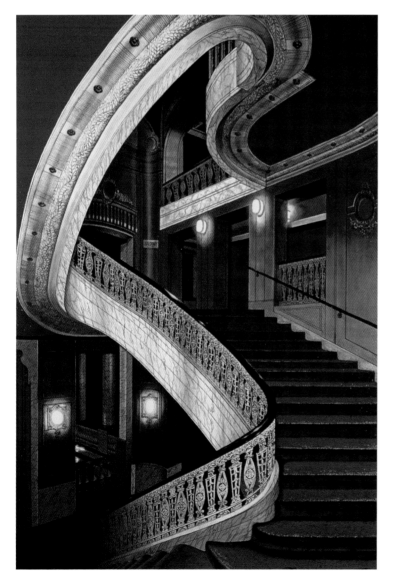

Locally, he has had solo exhibitions at Yamada Art Center, Artemisia Gallery, Around the Coyote Art Exposition, Neville-Sargent Gallery, and the Chicago Cultural Center.

He has taught art at universities and colleges, museums, art centers, summer camps, high schools and elementary schools in U.S. and Japan. He was an instructor at Yamada Art Center for 14 years. He had many commissioned work in U.S. and Japan. In the past two years, he had done illustrations for the *Strong Coffee* newspaper, and *Chicago Shimpo* (The Chicago Japanese American News).

201. (above)
Wacker Drive, Night, Fountain #2
1994
Oil and Acrylic on Canvas
48" x 36"

202. (left)
Chicago Theater
1993
Oil and Acrylic on Canvas
36" x 24"

Louis Zygadlo

"Abstract art, for me, should convey to the viewer a feeling of beauty and color while sometimes incorporating realistic themes. I ultimately believe art should have a true sense of beauty and inspire creative thoughts in those who view it.

In the painting perspective I call 'Dimensionalism', I paint three-dimensional abstract forms, yet placing them within the boundaries of realism. The Room series are a body of work inspired by five years of living in Wisconsin and walking in the silence of star-filled nights. These memories are kept within me and continue to be a guiding force."

BIOGRAPHY

Zygadlo is a native of Chicago. He worked as an engineer in plastic decorating for eight years before pursuing an art career. He then worked as a printer for three years to learn about color theory and blending. Using his new knowledge, he was able to turn a new oil-based paint which was only available in twelve colors into a library of 1,400 colors. Next he experimented with different plastic types to find a surface with the blending capabilities, translucence and adhesion he desired.

Zygadlo was listed in the ninth edition and won complimentary publication in the 10th edition of the *Encyclopedia of Living Artists*, published by ArtNetwork in Penn Valley, California. He was also featured in the November 1994 issue of *Decor* magazine. He has had solo and group exhibitions at Vedanta Gallery in Chicago. His work has also been shown at Eclectic Junction in Chicago and Galli Curcci in Evanston. He is currently represented by The Vedanta Gallery.

203. *Romantic Lighting*
1997
Oil on Acrylic
39½" x 21½"

204. *Butterflies at Midnight*
1996
Oil on Acrylic
40" x 32"

205. **Moon Lite Dreams**
1996
Oil on Acrylic
40" x 72"

Directory of Artists

Name	Telephone Number	E-Mail Address and Internet Home Page
Abed, David H.	(773) 342-5516	
Amft, Robert	(773) 743-3568	http://www.caconline.org/cacartists/AmftR/amftr.html
Baima, Christopher	(312) 217-2770	
Barth, Lee	(847) 825-3418	
	(414) 862-6109 summer	
Becker, Heather	(312) 654-0600 gallery	
Bent, Geoffrey	(630) 260-5869	
Black, George	(312) 360-1548	rops56@xsite.net
Burke, Mary	(847) 356-4133	
Ciurlionis, Rimas	(708) 749-8565	
Cole, Grace	(312) 362-9890 studio	http://security-one.com/colestudio
Colón, Peter A.	(219) 938-9403	skini@aol.com
		http://members.xoom.com/KalFarmProd/gallery.htm
Coren, Lois	(847) 869-6192	
Cosgrove, Bob	(708) 246-5435	
Daniel, Mary Reed	(773) 235-5477 voice mail	
DeLaCruz, Sharon	(312) 514-4144 voice mail	
Drake, Ascha Kells	(773) 489-4584	
Ellstrand, Beverly	(847) 825-1247	
Fairchild, Jason	(312) 455-1255	
Finnigan, Sheila	(847) 835-2144 studio	
Freilich, Judith	(847) 835-2393	rfreilich@nwu.edu
Fydryck, Walter A.	(773) 764-8588	walt@suba.com
		http://pages.ripco.com:8080/~fydryck
Gedroc, Maria	(773) 792-2957	
Gingrich, Mary	(847) 251-3829 studio	
Gould, Michael J.	(773) 327-9122	
Hirsch, Jean	(773) 871-7854 studio	
Hyde, J. Allen	(847) 966-5241	
Ketcham, Margaret D.	(773) 262-5285	
King, Jill I.	(847) 475-5393	
Koelle, Eric	(847) 492-8123	
Lader, Deborah Maris	(773) 235-3712 studio	
Lah, Min-Ja Oh	(630) 736-2693	
Langmar, Itala	(847) 251-0427	
McElroy, David	(773) 761-6136	
Medvey, Monika	(312) 850-3874	
Mesplé, James	(773) 862-7297	
Miller, Dale	(847) 537-7571	
Mitchell, Michele Maria	(773) 262-5781	
Mocek, Betty Ann	(312) 563-1785 studio	
Moses, Jacqueline	(847) 677-5805	
Napier, Richard	(773) 235-1499	

Name	Telephone Number	E–Mail Address and Internet Home Page
Newman, Kathleen Putnam	(708) 361-0679	
Oehmke, Julia DelNagro	(708) 672-3255	
Ostlund, James Michael	(773) 262-5781	
Parenteau, Lisa	(773) 929-7714	
Paschke, Ed	(312) 440-0055 gallery	
Pelnar, Mark	(847) 540-6867	
Pinsky, Joanna	(312) 266-9473 gallery	
Price, Rita F.	(847) 945-5598 studio	
Pristas, Tracy Lynn	(773) 871-7854 studio	
Robinson, Tom	(773) 477-7913 studio	
Rush, John	(847) 869-2078	
Ryding, Jeanine Coupe	(847) 869-7091 studio	
Samuels, Fern	(312) 654-0017	
Scekic, Vera	(773) 388-9844	robo53330@aol.com
Segami, Amy Lee	(312) 635-5123 voice mail	segami@aol.com
Sokulski, Florette	(847) 426-6838	
Stecker, Gregg M.	(847) 256-4106	
Thorne, Charlie B.	(312) 486-7969 studio	
Tracy, Lee	(312) 266-4955	
Tyler, Al	(773) 973-0640	
Villa, Gabriel	(312) 829-5117	
Volpe, Doris	(847) 234-3531	
Walsh, Aleksander Balos	(773) 804-1552	
Webb, Duncan	(312) 573-1157 gallery	
Weiss, Nina	(773) 252-4913	
Witty, Donna Jill	(815) 338-0849 studio	
Wroblewski, Dan	(708) 424-6469	
Yamada, Takeshi	(312) 243-0032	
Zygadlo, Louis	(312) 432-0708 gallery	lfzstudio@snd.softfarm.com http://www.lightwizard.com/lfzstudio